Carving Cigar Hu
with Tom Wolfe

Text written with and photography
by Douglas Congdon-Martin

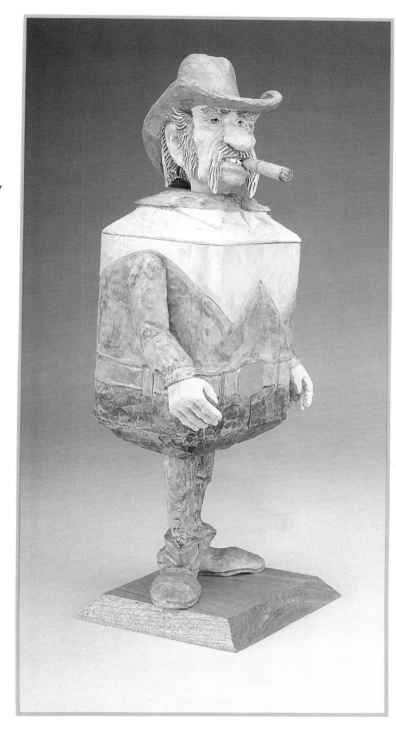

4880 Lower Valley Road, Atglen, PA 19310 USA

Book Design by: Laurie A. Smucker

ISBN: 0-7643-0420-8
Printed in the United States of America

Contents

Published by Schiffer Publishing Ltd.
4880 Lower Valley Road
Atglen, PA 19310
Phone: (610) 593-1777; Fax: (610) 593-2002
E-mail: schifferbk@aol.com
Please write for a free catalog.
This book may be purchased from the publisher.
Please include $3.95 for shipping.
Try your bookstore first.

We are interested in hearing from authors
with book ideas on related subjects.

Introduction

I was smoking cigars long before that was such a stylish thing to do. I have always loved the rich aroma and smooth taste of a good cigar. Nothing quite surpasses the pleasure of a fine smoke. So I am not surprised at the growing popularity of cigar smoking among young men and women. Though it is still a little sinful, it is a relatively safe indulgence, at least when compared to cigarettes.

The only problem I have with this new trend is that it is driving up the cost of cigars. It used to be that you could find a pretty good imported cigar for under a dollar. Now I have to take out a second mortgage to support my habit.

Perhaps that is why there is such an interest in humidors. A cigar stored at the proper temperature and humidity will stay fresh for years, or even decades. In fact, some of the hottest auctions taking place these days are for vintage cigars. Like old wines, some people believe that they improve with age.

For that to happen, they must be stored in a controlled environment with a humidity near 70% and a temperature of 70 degrees. If the humidity goes to 68% or below, the cigar slowly dries out. If it reaches 80%, it is likely to develop an unsightly and unsmokable mold. While cool temperatures will not cause much problem, warm temperatures encourage the growth of tobacco worms.

The humidor provides the controlled environment that is needed to protect your investment. If it is not opened too frequently, an even temperature and humidity can be maintained. Meters are now available from woodworking supply houses that can measure the humidity and allow for adjustments. Adjustable Humidifiers are also available. If you are looking for something less high-tech, a sponge soaked in a mixture of 50% water and 50% propylene glycol, a chemical available at some drugstores or chemical supply houses. The mixture allows water to evaporate at just the right rate to create 70% humidity. You must freshen the solution regularly to keep the same rate of evaporation.

The humidors in this book represent a variety of styles, most of the them carved at least in part. I hope you enjoy what you see and will attempt some of the projects for yourself.

Carving the Project

The box is made of Jelutong. This wood has many characteristics in common with cedar and withstands the moisture of the humidor in the same way. This is a simple butt-fitted box. The walls are about 1/2" thick. The inside measurements of the box are deep enough for a long cigar. This one is 6-1/2" deep which will work for an American cigar, though it will be a little short for imported brands. Inside it is 5" wide by 4" from front to back.

The bottom of the box is 1-1/4" to 1-1/2" thick. This gives me room to carve it.

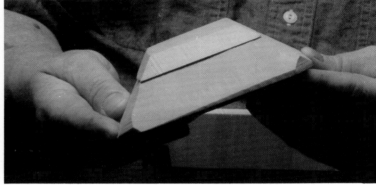

The lid is about 2-1/2" thick. I didn't have a piece thick enough so I glued two pieces together. The thinner piece will become the collar of the shirt, which will camouflage the glue line.

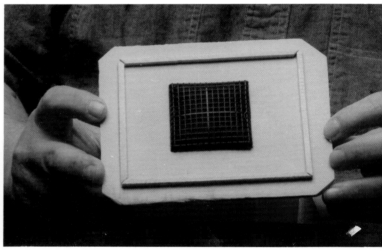

On the underside of the lid, I have added a lip so it will fit inside the box, making it more airtight. The humidifier will also be installed here, but we'll learn more about that later. The rim should fit tightly. This will keep the air out and the moisture in.

The pattern of the head is cut on a piece of basswood about 4" thick.

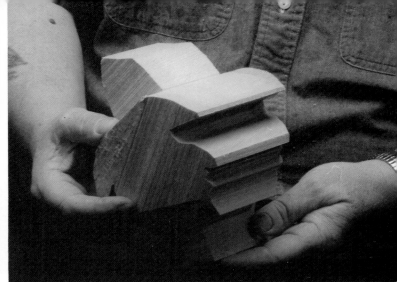

I can take away a lot of excess on the band saw. The brim of the hat is going to be almost round, so I measure its depth...

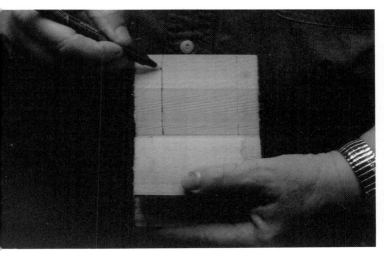

and transfer it to the width.

The result of the bandsaw work.

I can also trim some off the lower face and neck.

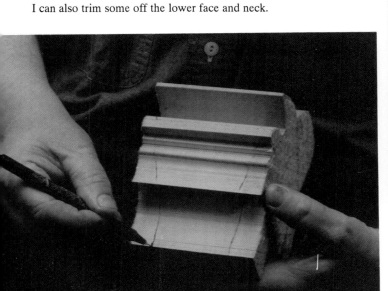

Remark the line of the brim.

5

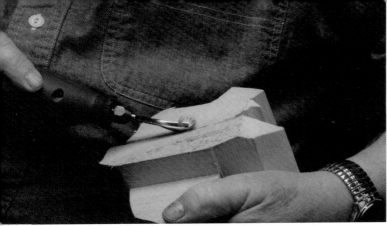
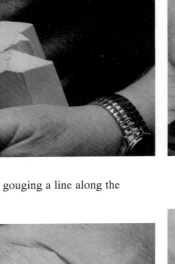

I'm going to start with a power chisel, gouging a line along the underside of the brim of the hat.

Back to power chisel to round the head.

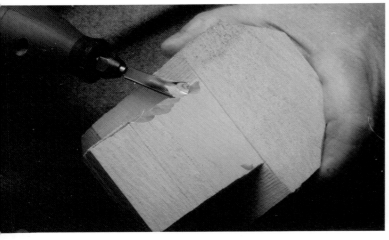
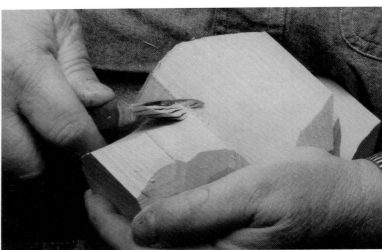

Switching to a half-round chisel I knock the corners off the crown of the hat.

Work down the corner of the hat's crown. I always begin the rounding process by taking the corners down and carving things to an octagonal shape.

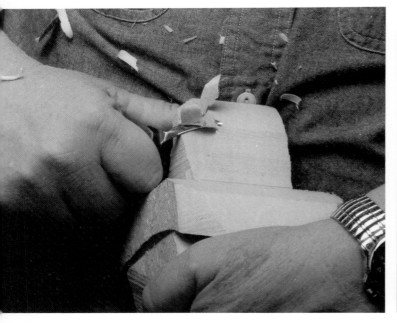
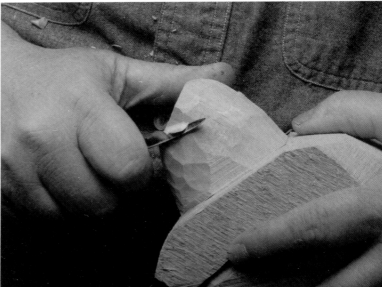

As sometimes happens, it turns out to be easier with a knife. The secret of easy carving is finding the tool that will work best in a particular situation. Don't be afraid to experiment, trying different tools until you happen upon the one that works just right.

With the corners cut down, round the sides and the top.

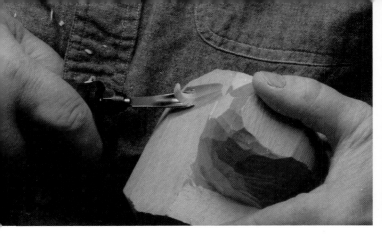

To remove the excess from the top of the brim, I again return to the power chisel. You can do this in a number of ways, including a hand gouge or a rotary tool.

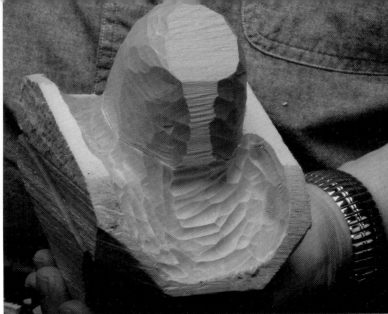

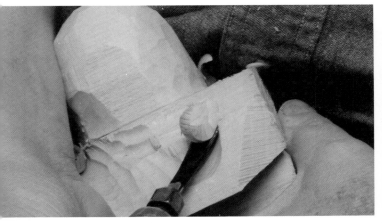

Work your way back to the edge of the crown.

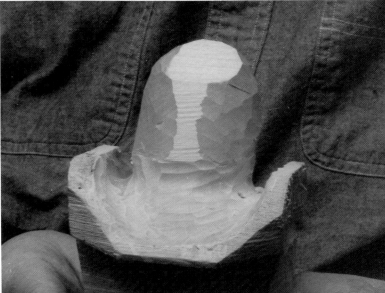

Progress.

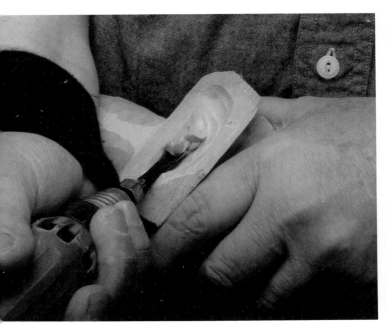

Do the same at the front of the brim.

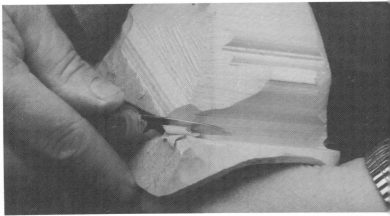

Continue to deepen the cut until about this point.

7

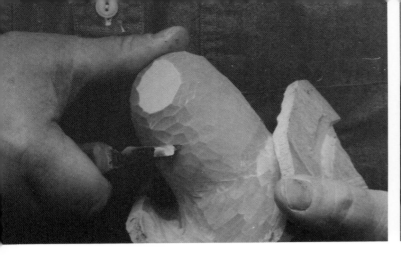

Now I clean things up with hand tools.

Now round the underside of the brim back to the head.

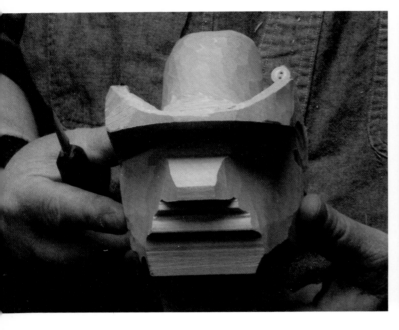

Knock off the corners of the face under the brim. This should take the head to this point.

I am carving this area before I work on the sides of the head, because the size of the hat determines the size of the head.

Do the same at the back corners of the head. Make a stop cut under the brim and come back to it from the hair. The wood should just pop off.

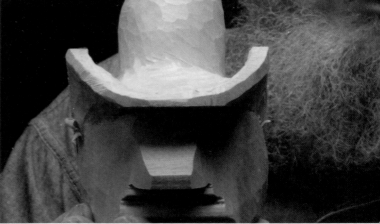

I can see that the head is too wide at the ears.

Reduce the sides, but go slowly. I want plenty material left for the ears, especially at the top where they overlap the hat.

Now I can continue thinning the hat brim.

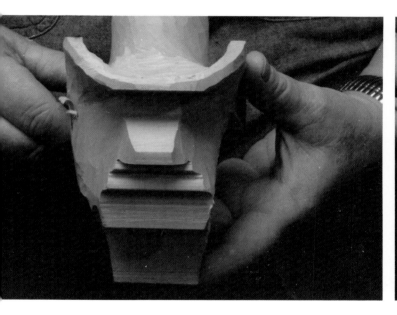

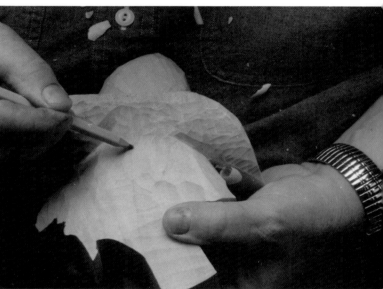

With one side done you can see how much I've taken it down.

Draw a vertical line on the side of the head, about halfway back, which is the front edge of the ear. Draw the ear. The ear hole should be at the back of the jaw. The ear should attach at the top of the ear so it is about even with the eyes.

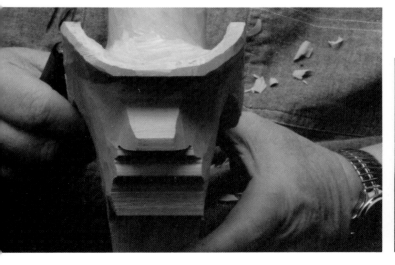

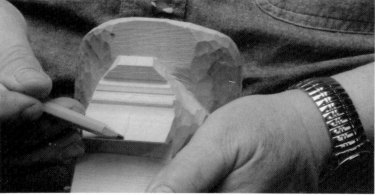

Both sides done.

Mark the vertical center line of the head..

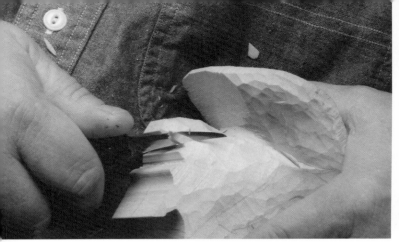

Knock off the bottom corners of the nose, cutting back to the face at about a 45 degree angle.

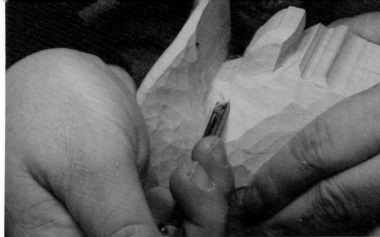

Use a gouge to begin forming the eye socket. Cut from the temple back to the bridge of the nose.

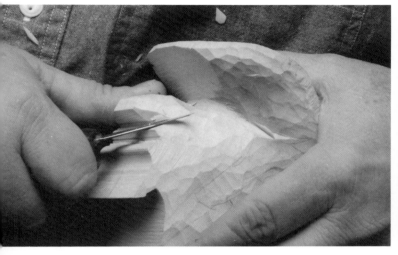

Trim back to this line from the upper lip, flush with the face.

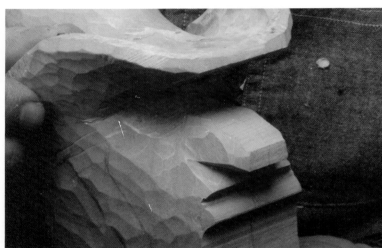

The result.

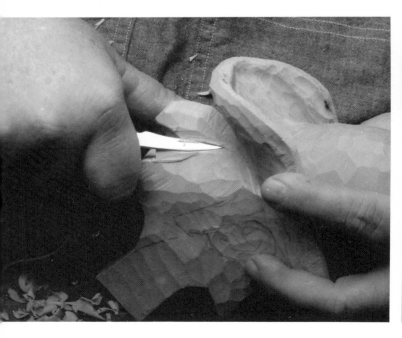

Continue to narrow the nose. Make a stop down the side of the nose and trim back to it from the cheek.

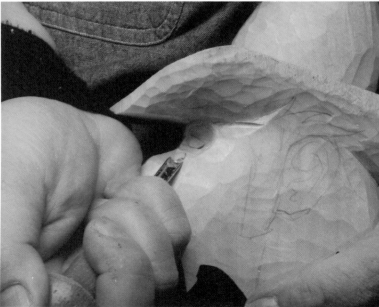

Run the gouge up the side of the nose into the eyesocket.

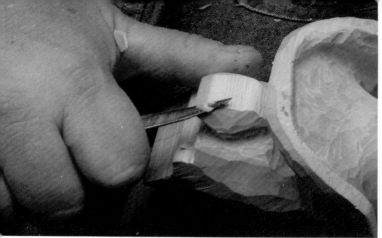

Clean up the area, taking away the saw marks and shaping the nose.

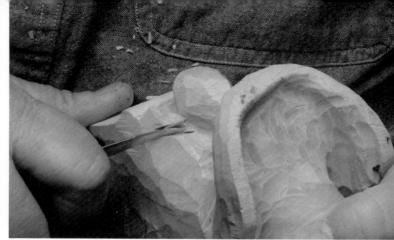

Third, cut down to the line from the cheek.

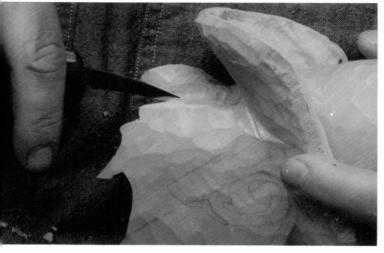

To make the smile line I use three cuts. First cut beside the nostril.

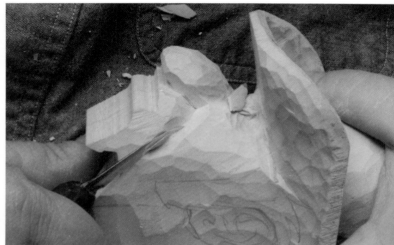

Carry the line down beside the mouth.

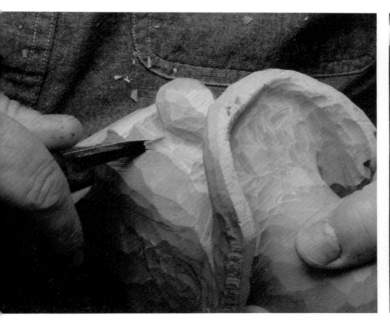

Second, cut along the smile line from the lip.

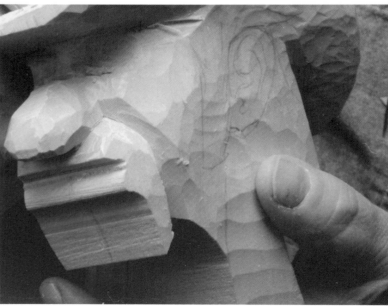

The result. This cut goes behind the large drooping moustache.

11

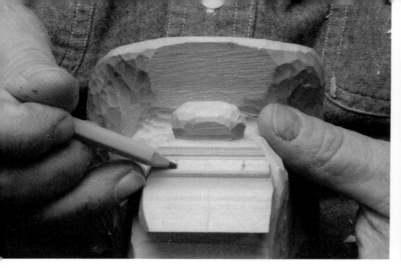

Mark the bottom lip about as wide as the nose.

Mark the area below the chin for removal and take it out with a gouge.

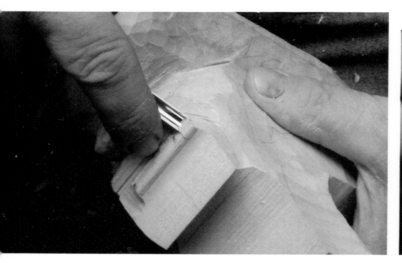

With a chisel, pop off the excess beside the lips.

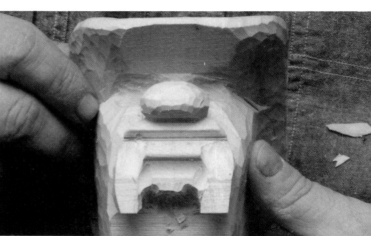

The result.

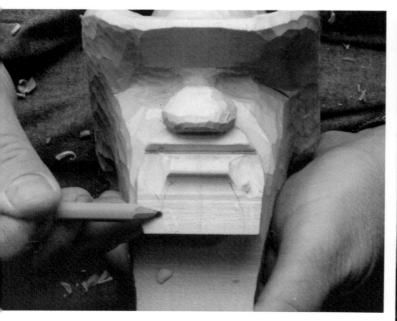

The result. We can now mark the inside line of the moustache on both sides.

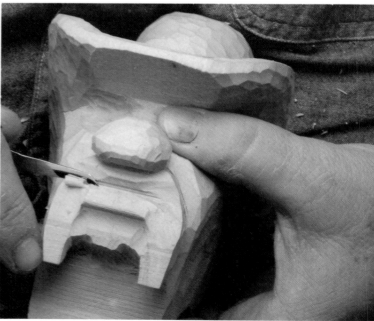

Give a little shape to the moustache.

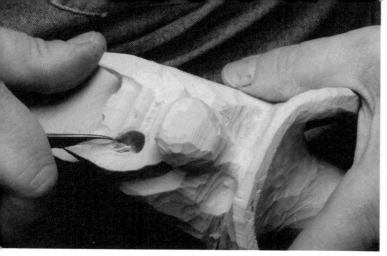

I have drilled a hole for the cigar at one side of the mouth, and am blending the hole into the moustache.

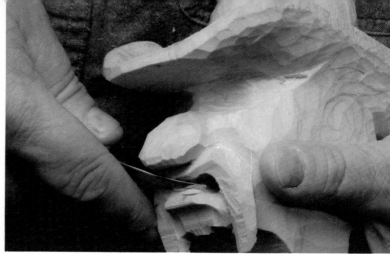

Cut the top of the lower lip back to the tooth line and trim it off.

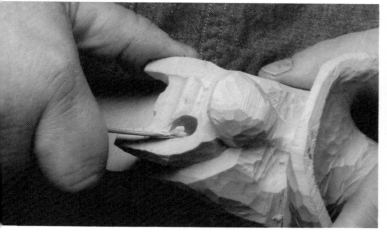

Continue to refine the moustache line. Make a stop on the line...

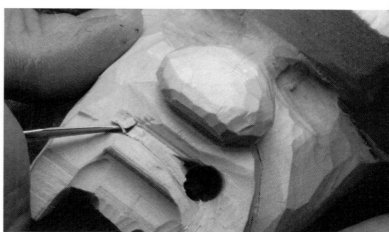

Cut the other corner of the mouth, leaving the surface for the teeth.

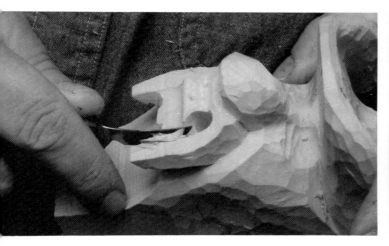

and trim back to it from the chin.

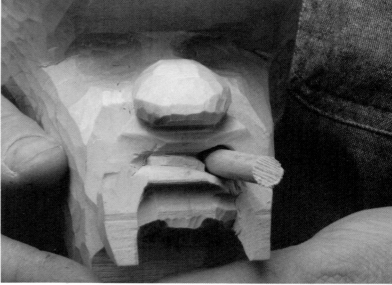

Progress. The dowel holds the position for the cigar, giving a clearer view of the carving.

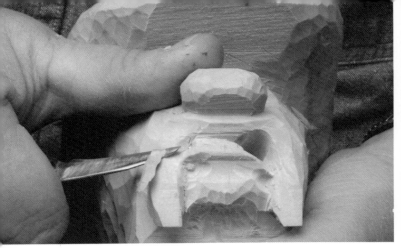

Continue to refine, shaping the moustache and lip...

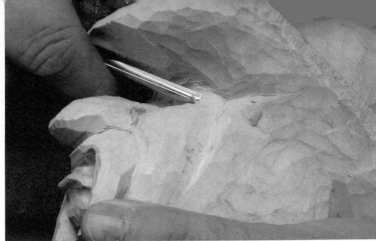

Round the eyesocket back into the temple.

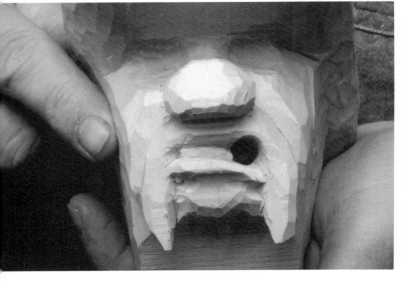

for this result.

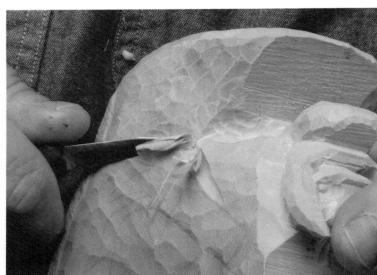

Repeat the process on the other side.

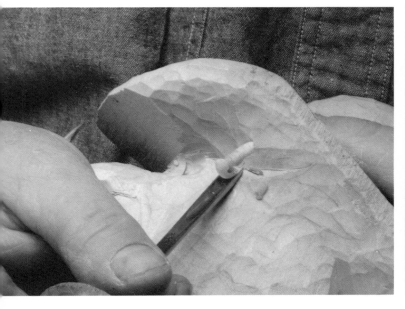

Now I'll move to the side and bring a gouge up the face along the hairline, creating a separation.

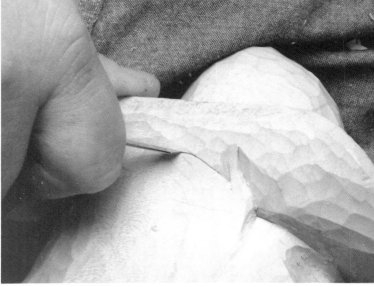

I want the hair to come up against the brim of the hat, overlapping it just a bit. To do this I cut a stop along the line of the hair...

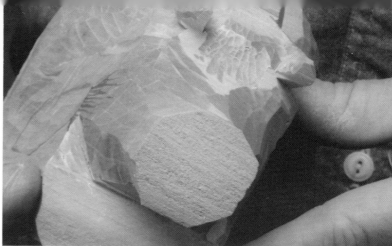

and make a flat cut back to it from the brim. The brim needs to stay flat to look natural.

The result.

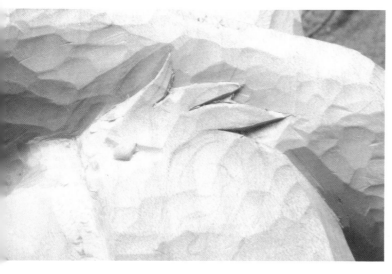

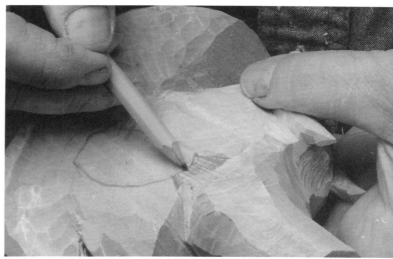

The result.

Mark the area below the ear, between the hair and the jaw line for removal.

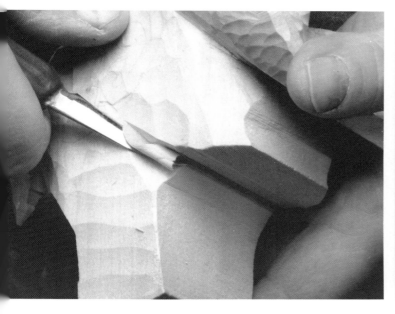

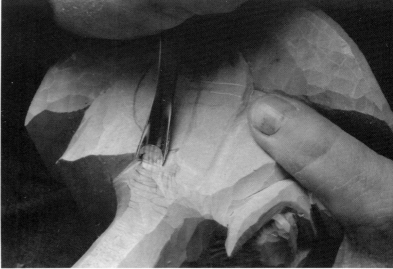

Knock the corners off the neck.

I use a gouge to clean it out. A common mistake is to make this cut not deep enough, giving the character the look of having a goiter.

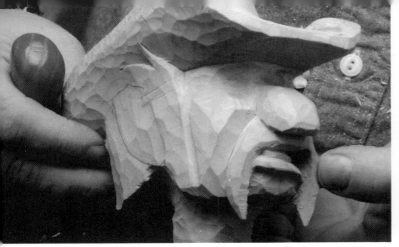

The result.

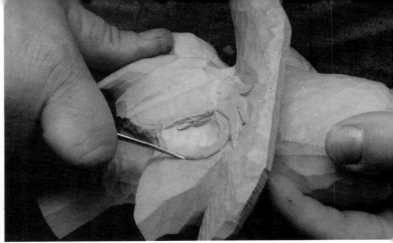

cut a stop around it...

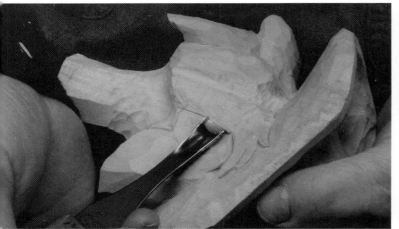

Cut a stop in the sideburn and cup the ear back to it.

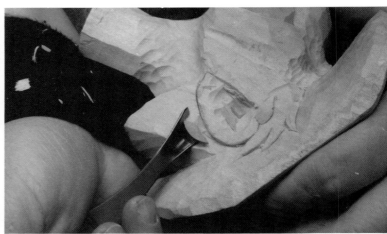

and make a cup cut back to the stop from the hairline.

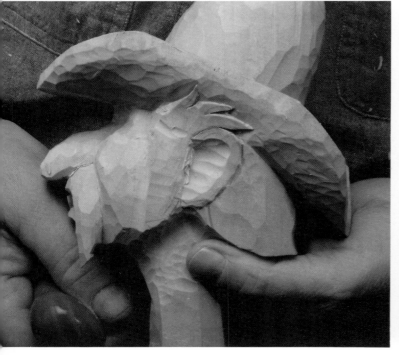

The result. Redraw the line behind the ear...

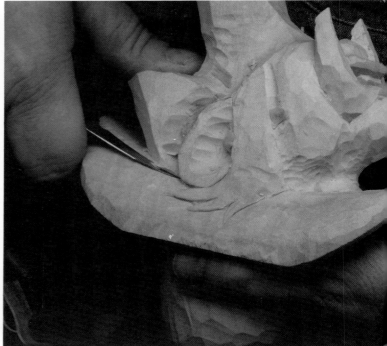

Carry the brim back behind the ear, cutting along the surface.

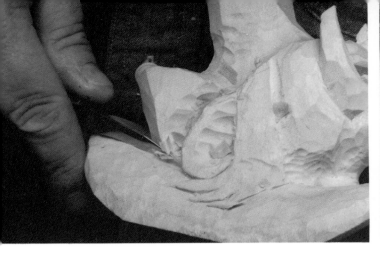

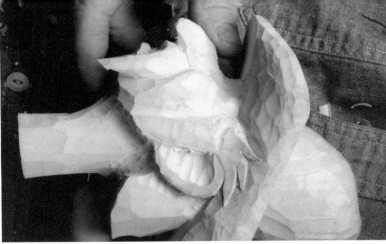

Cut it off at the hairline. The hair looks like it is growing behind the ear, so we need to clean it up a little.

Progress.

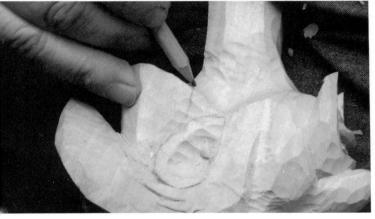

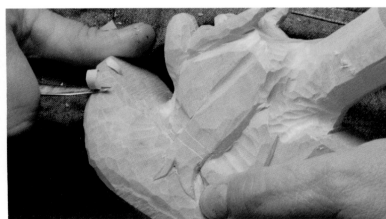

Draw the line...

Go over the whole head, cleaning everything up.

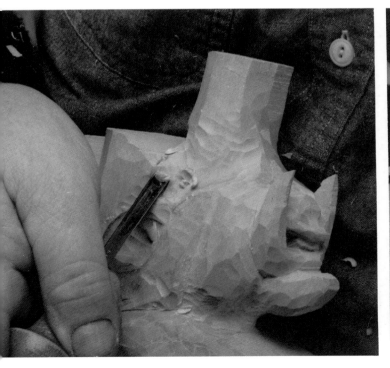

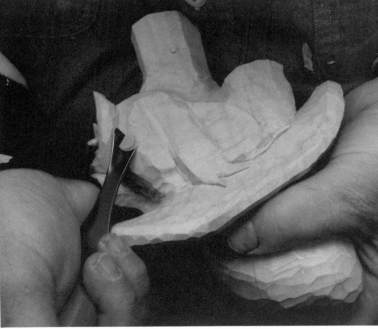

and gouge it out.

To create the hollow of the cheek, come down from the cheekbones with a gouge.

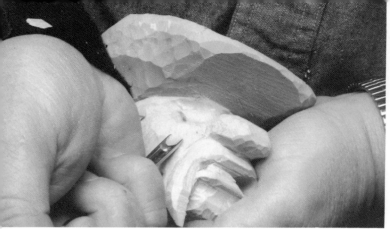

Gouge a line a little above the cheek line.

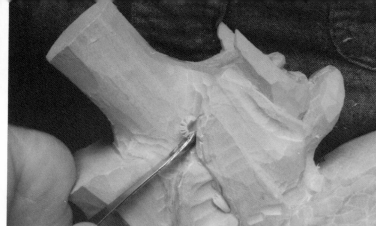

Run a v-tool behind the bottom of the sideburn to bring it out from the neck.

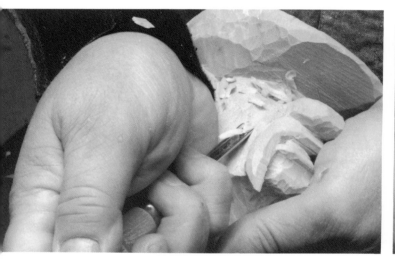

I have found that the most efficient and safest position for the palm gouge is this. The movement is in the wrist, pulling the chisel toward you with short controlled strokes.

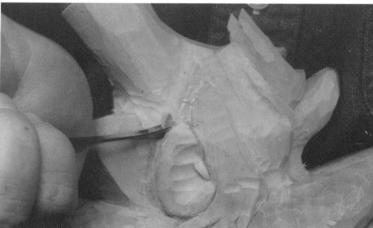

Do the same behind the lower ear.

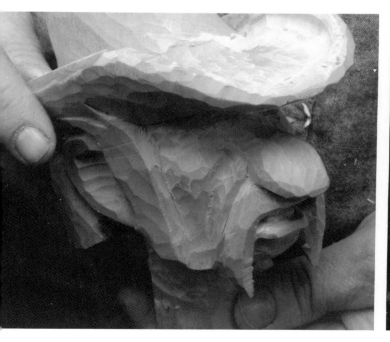

Progress.

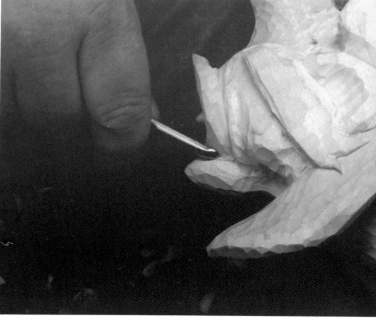

On the underside of the nose, cut the nostrils.

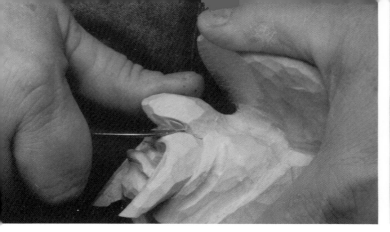

Trim off the waste at the moustache.

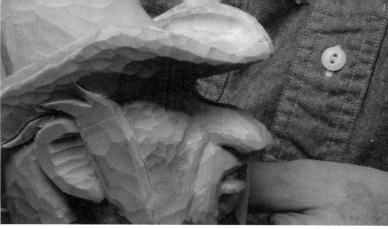

This is the effect I was after, the kind of big nose you sometimes see on thin people. My dad used to call them "Ecclesiastical" noses.

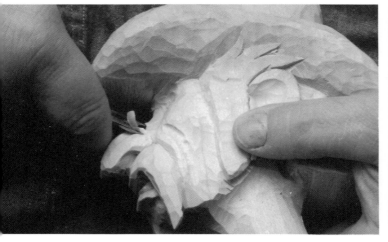

Come over the nostril flare with the same tool. Carry the cut back to the face and just let it break off.

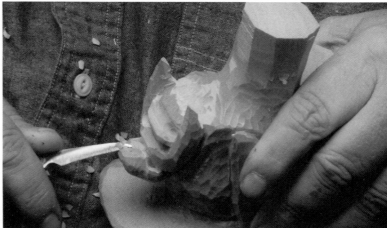

Trim up the end of the nose...

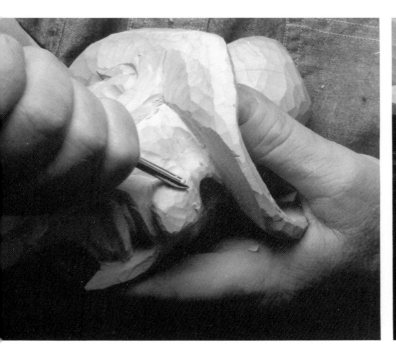

Blend the line into the top of the nose.

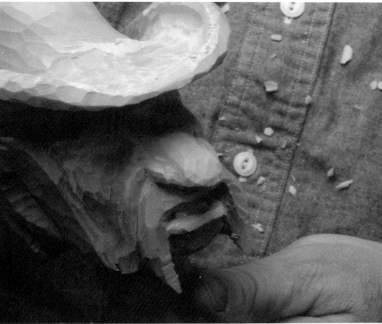

to give it a little more of a button look.

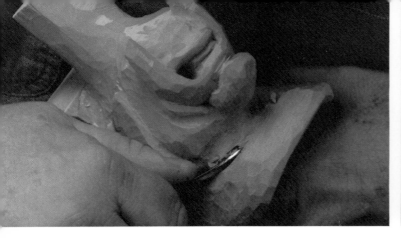

I need to carve under the brim of the hat to make room for an eyebrow.

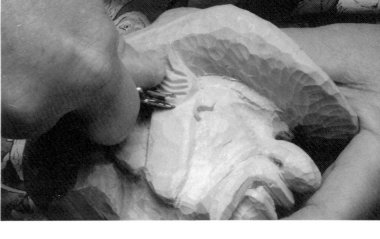

When that is done, I use a v-tool to create hair lines. Sometimes I use a veiner for this job, which gives it a softer look. In this case I want the hair to have a grainier look.

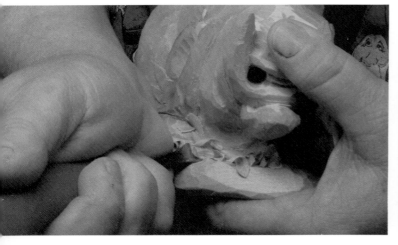

If you keep a finger on the opposite side of the brim, your mind tells you when you are getting too thin.

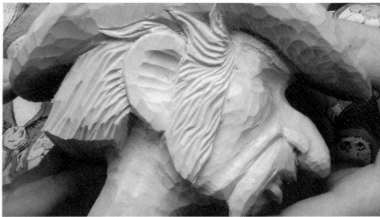

Continue down the sideburn and the hair behind the ear. Avoid straight lines. Look for natural patterns and follow them. The result you are after is kind of a kept-unkept look, not like he just combed his hair and not like he never combs his hair.

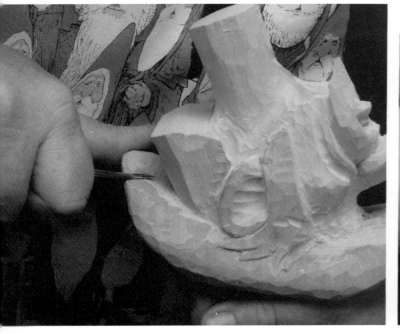

Go over the piece and smooth it up. Look for lumps and marks that don't look right and fix 'em up.

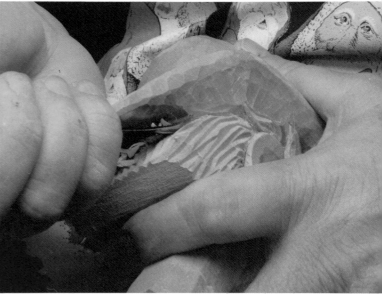

Continue around the back of the head.

20

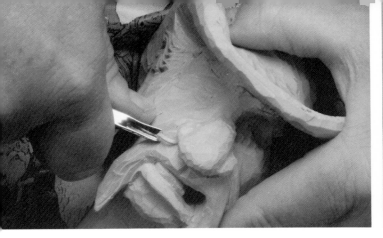

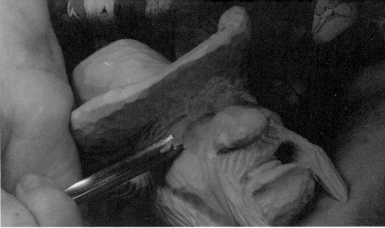

The droop of the moustache goes with the grain so it isn't overly fragile. Add hair to the moustache.

With a larger gouge, smooth out the eyesocket. It is important to get both sides even, with the same shape and position. For a realistic eye you need to carve it out, rather than leaving a mound. The eye mound gives a googly-eyed effect.

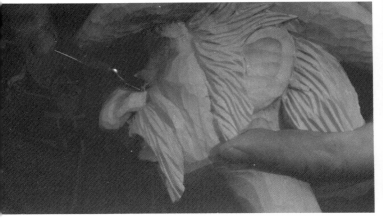

While I have the v-tool I'm going to go over the top of the nostril flare and give it a little more definition.

The position of the eyes is set by imagining the face as being five eye widths across. Put dots at the ends of the second and fourth eye widths.

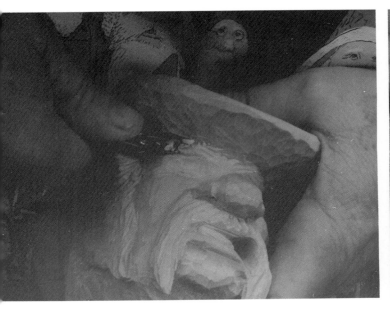

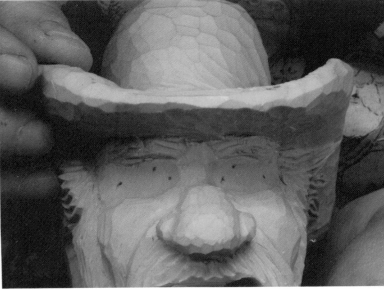

Continue by adding hair lines to the eyebrows.

At the highest portion of the upper lid, add dots at the zenith points. A curved line through this point would give nice almond eyes.

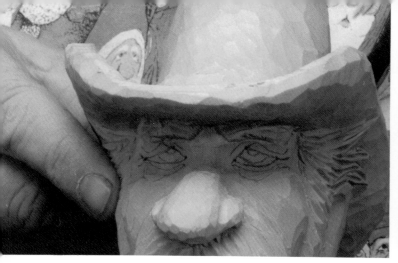

I have chosen to go straight up to the line from the inside corner dot, then sweep down to the outside. This gives a sadder look to the eye. It doesn't hurt to draw in the whole eye before carving.

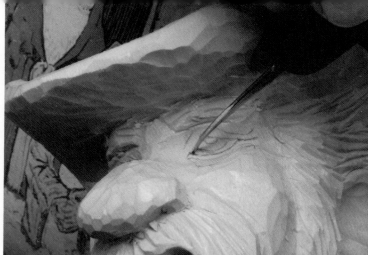

Do the same along the upper lid.

This turned down knife works well for carving the eyes.

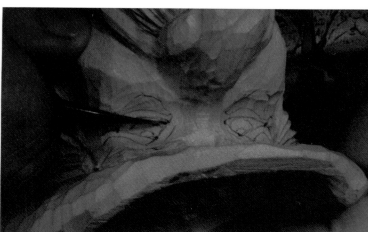

Cut back into the corner along the surface of the eye to knock out the triangle. You want this corner to be deep enough to create shadow.

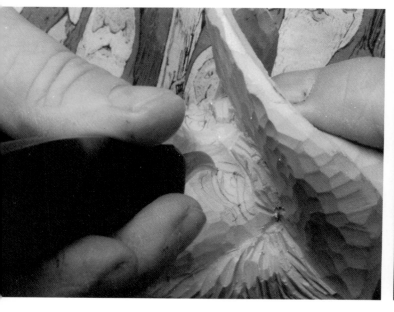

Starting at the inside corner make a fairly deep cut along the line of the lower lid.

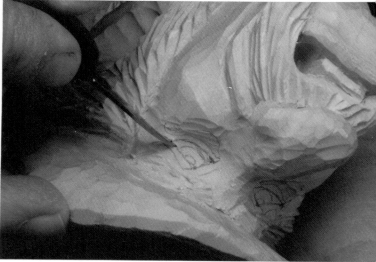

Do the same at the outside corner...along one lid...

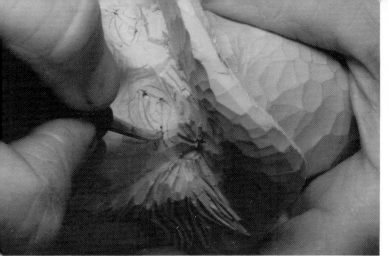

along the other....

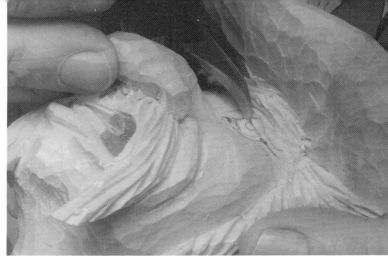

the other...

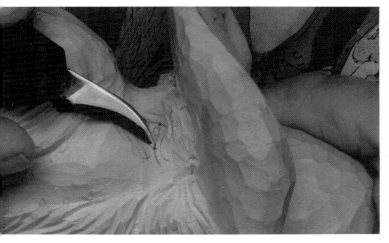

and back from the eye surface.

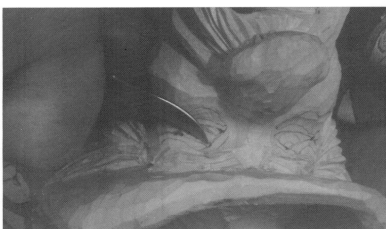

and back from the center.

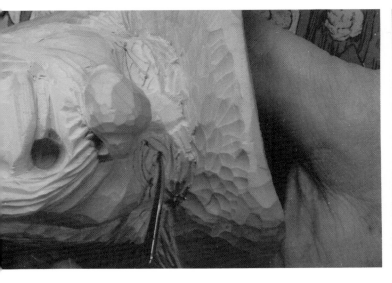

At the zenith point cut along the upper lid in one direction...

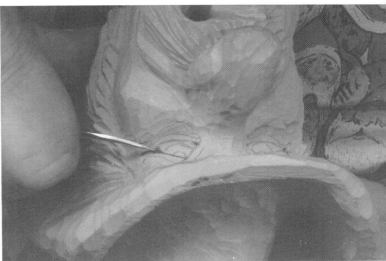

Connect the three corners all around...

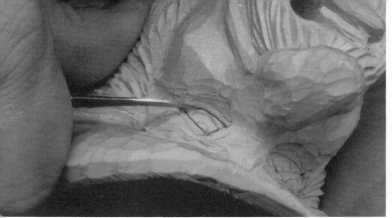

sweeping along the bottom.

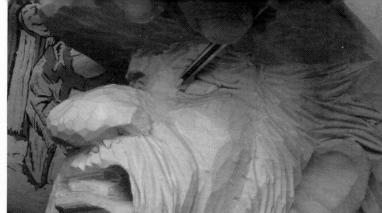

With a veiner, go over the lines of the eyelids.

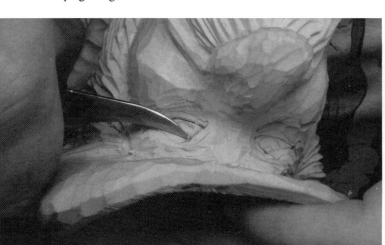

Flatten the eyeball back to the stop cut. The actual result will be a nice eyeball shape. With the hat brim it is hard to get in here, be patient and work at it.

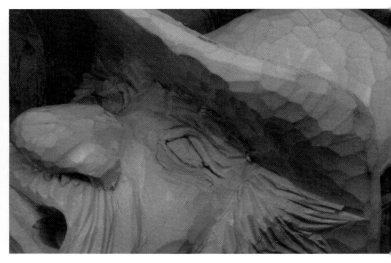

This turned under eyelid heightens the droopy effect I'm after.

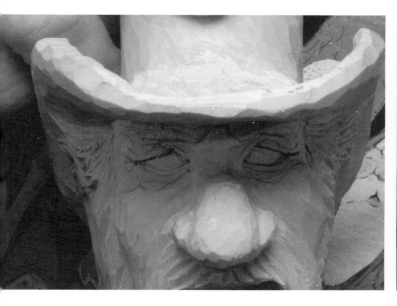

Progress.

24

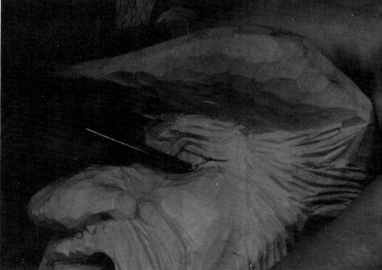

The lower lid should be thin so it doesn't look like a bag, but be careful not to break into the eye itself. At the outside, turn the cut down to create a natural looking crow's foot.

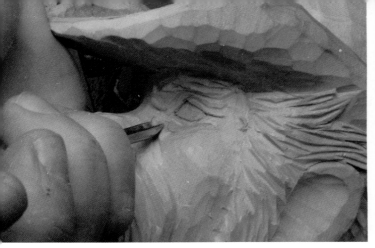

I'm going to deepen the smile line between the cheek and the nose, to add character.

I will also hollow out a little more of the cheek to give him a gaunter look.

Add the bag under the eye with lower edge of the veiner against the wood.

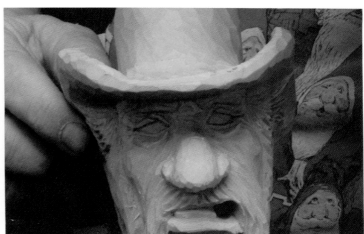

Progress.

As I look at it I've decided to add just one more little wrinkle along the smile line.

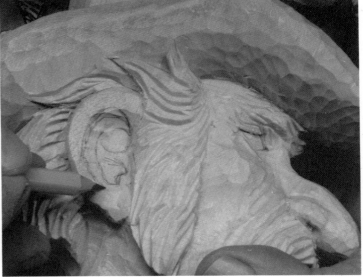

Draw in the pattern of the ear.

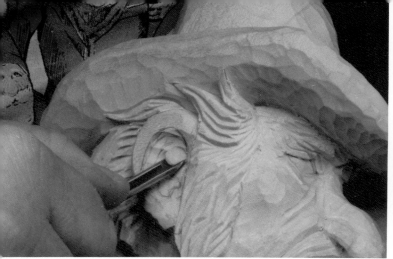

With a gouge carve the depression at the top of the ear...

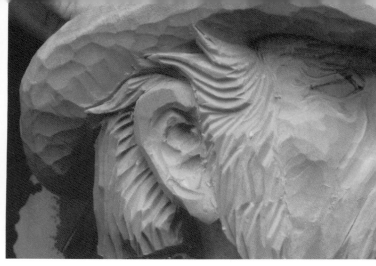

With a veiner create the crease around the outside of the ear. The result.

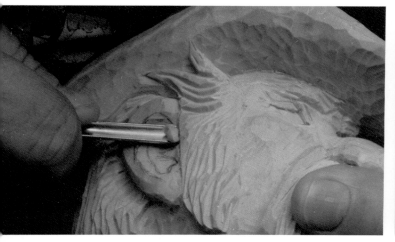

and pop it out.

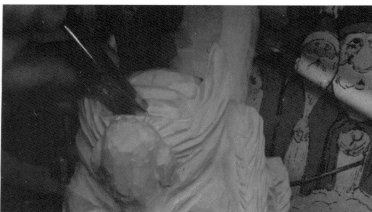

The bottom teeth show in this figure. Make a v-cut in the middle and work your way out to define the teeth.

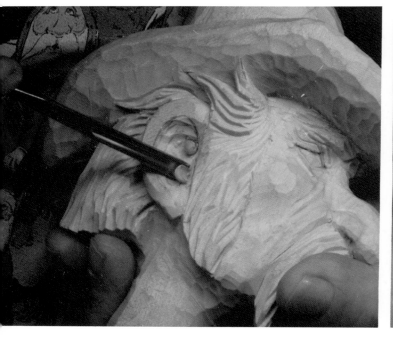

Do the same at the bottom.

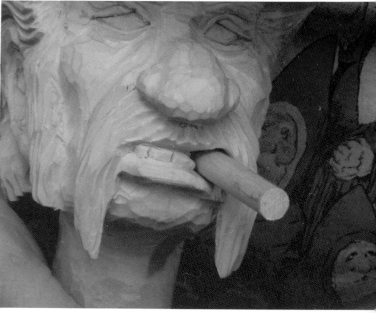

The result. The cigar fits in the gap where our friend lost a tooth in a fight over a biscuit in the boarding house.

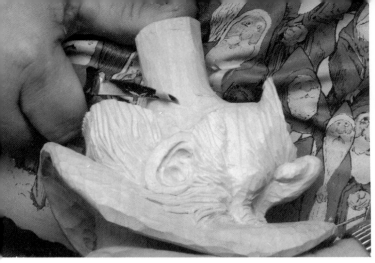

A final clean up of the head.

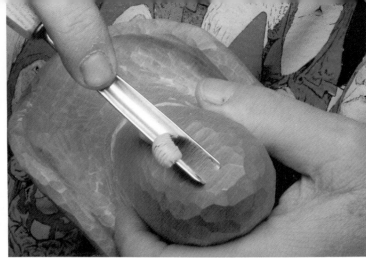

Use a gouge to create a "Montana" crease up the front of the crown.

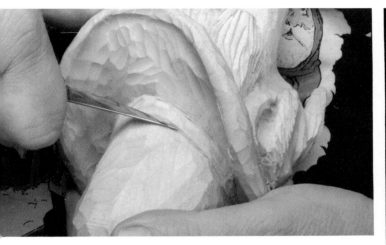

Looking at the hat, I decided it needed a band. This is done simply by cutting a stop around the top edge of the hatband and trimming back to it from the crown.

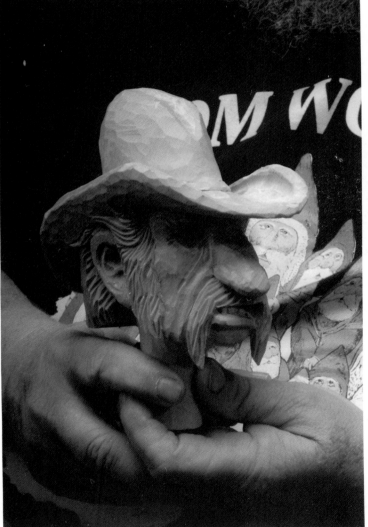

Progress.

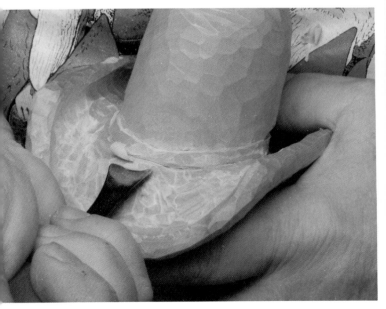

Do the same at the lower edge of the hatband, trimming back from the brim with a flatter gouge to smooth things out.

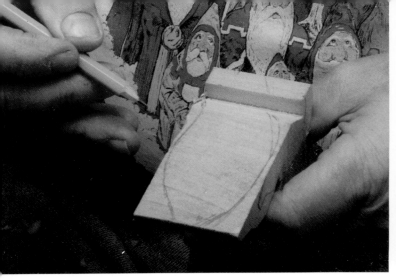

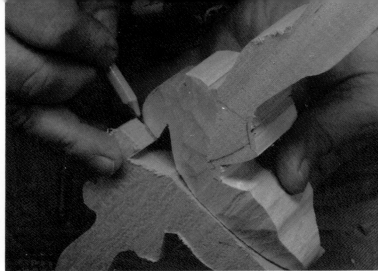

Moving to the legs, draw in the outline of the sole. Remember you need a left and a right. Start with one or the other.

By holding the shaped foot sole to sole with the other blank, you can trace the outline of the sole.

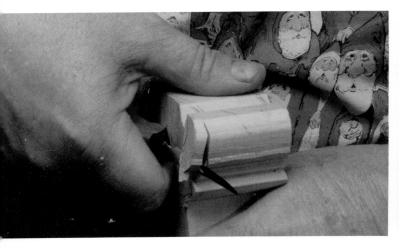

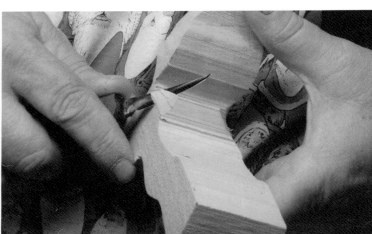

Knock off the corners.

Knock off the corners of the upper boot.

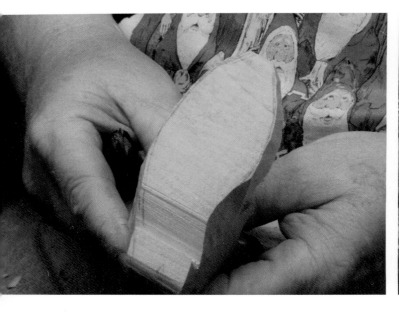

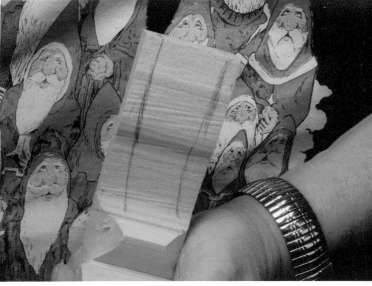

to bring the foot down to the outline of the sole.

I've drawn in the lower leg, making it curve in a little at the bottom for a bowlegged look.

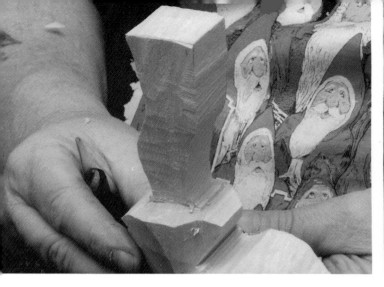

Square up the legs. As I said before, to get to a good round carving you first need to go to square then to octagon.

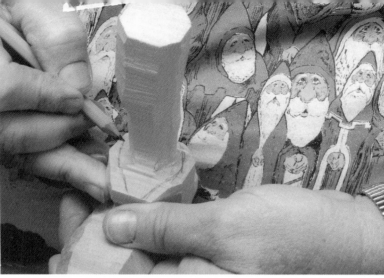

I need to narrow the top of the boots.

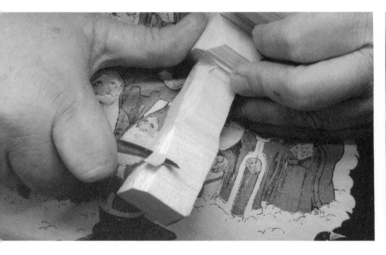

Now knock off the corners to go to an octagon.

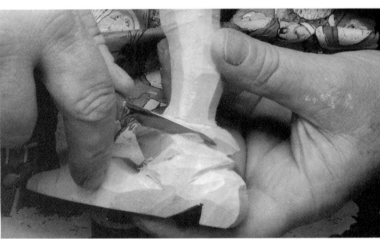

These old, droopy boots need a lot of wrinkles. They are made with simple v-cuts radiating from the stress points.

Carry the octagon all the way down the corners of the boot.

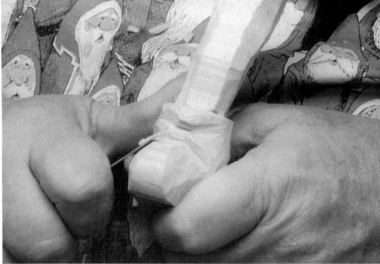

Shape the heel to make it look more like a high-heeled boot.

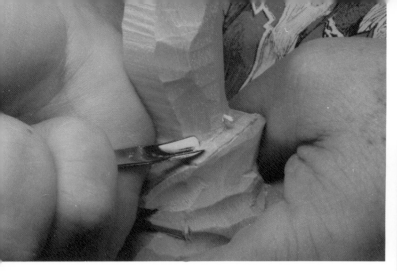

Hollow out the top of the boot.

Cut the line with a v-tool, laying it down a little bit on the boot side.

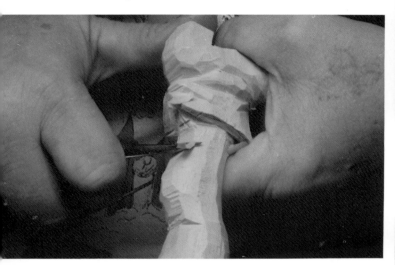

Round the leg.

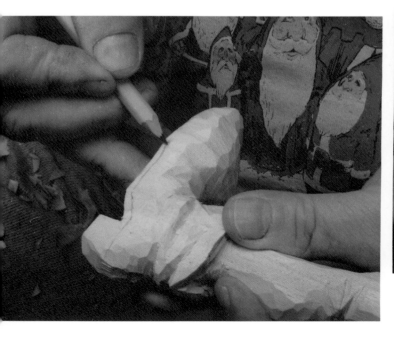

Draw the line of the sole.

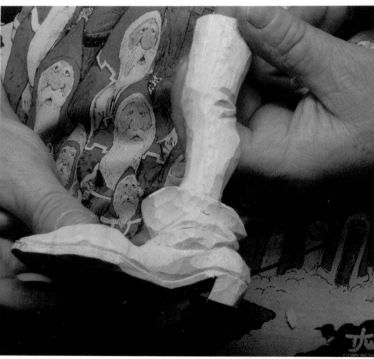

The finished boot. The large size of the foot needs to be exaggerated to support the humidor.

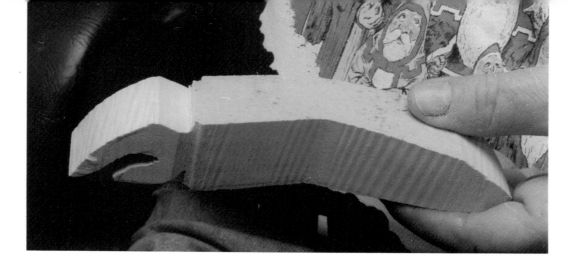

The arm blank.

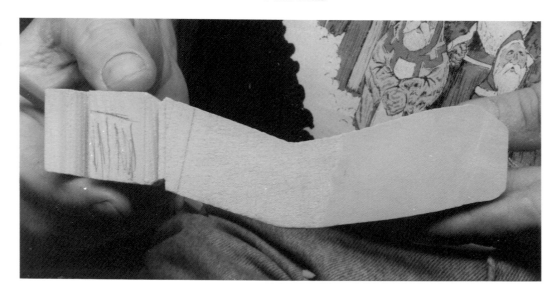

To avoid two right arms, mark the area to be removed beside the thumb on both arms and double check before carving.

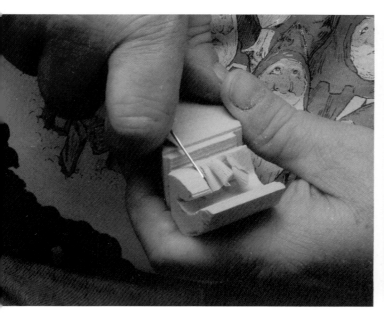

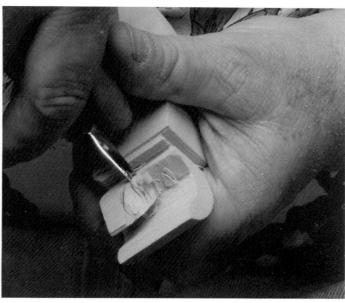

Cut a stop beside the thumb... and cut back to it.

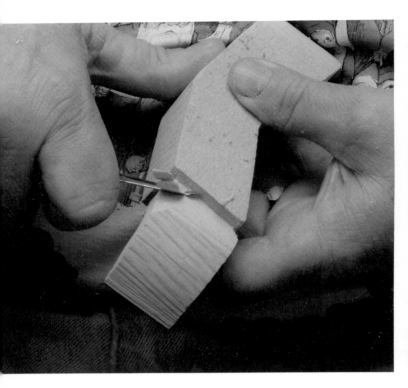

Take everything to octagon.

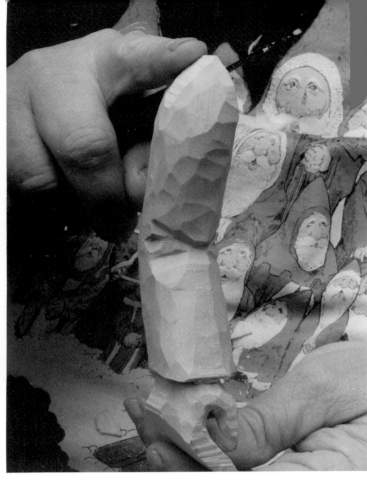

The arm is finished, waiting for the hand to be done. Note the v-cuts at the elbow to show folds.

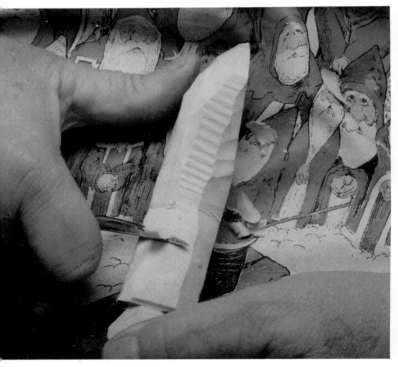

Continue rounding it off.

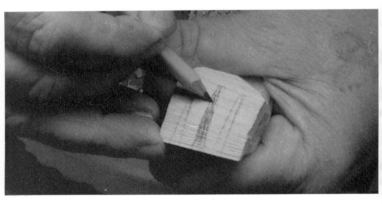

Draw in the fingers.

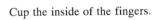

Cup the inside of the fingers.

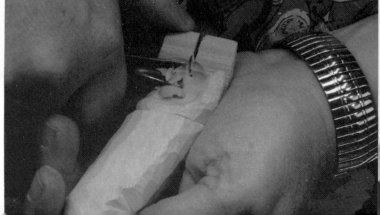

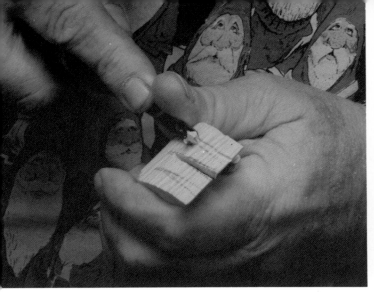

Having made the middle split on the bandsaw, I'm making the other separations with a v-tool.

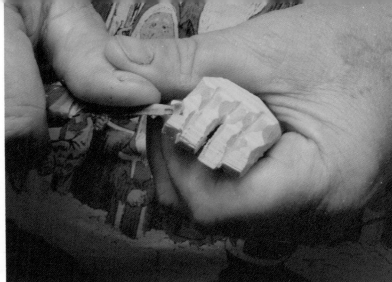

Shape the fingers, leaving the knuckles full.

Cut the fingers to different lengths.

Use a small gouge to separate between the main knuckles, carrying the line to the back of the hand.

Separate on the inside of the fingers as well.

Use a v-tool to make the folds on the inside of the fingers.

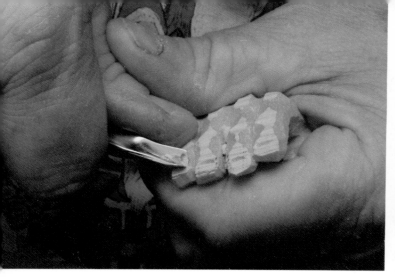

The same tool can be used for the back of the fingernail.

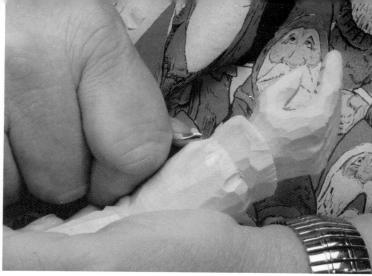

With a gouge, make the gathered folds above the cuff.

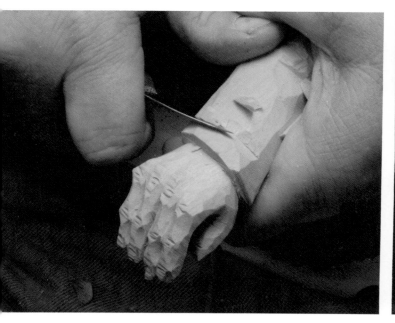

Make a v-cut for the line of the cuff.

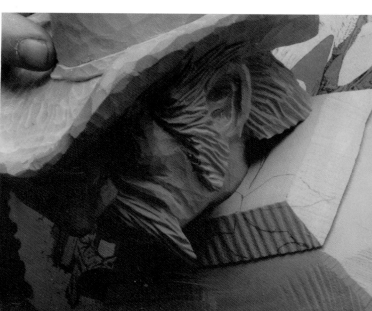

Drill a hole in the top and fit the head in it. When the fit is made, draw the neckerchief.

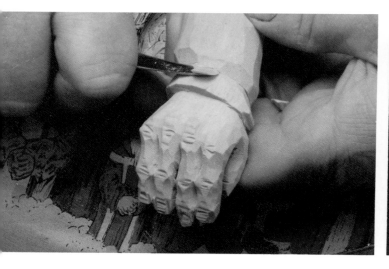

Trim back to it.

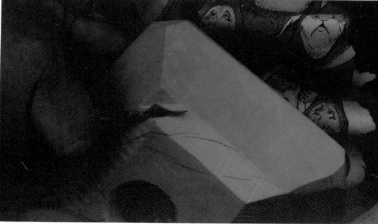

Trim around the kerchief.

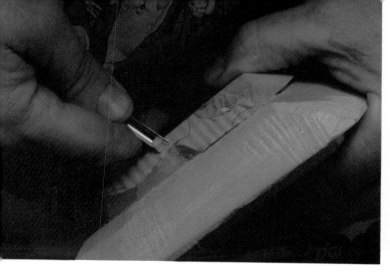

Carve around the knot.

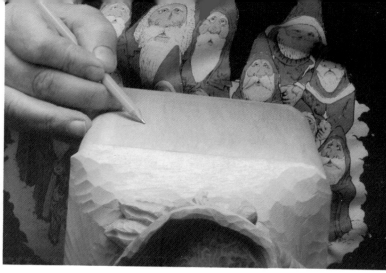

With the head in place, draw in the western shirt.

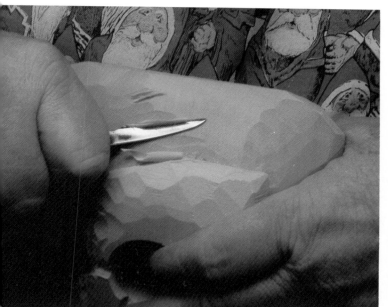

Finish shaping the kerchief and the shoulders...

The bottom edge of the belt is even with the base. Draw in the buckle and the belt.

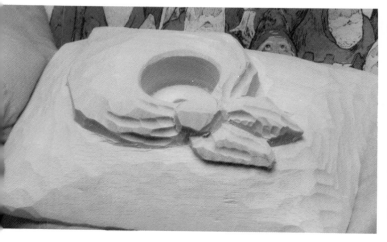

for this result.

Start at the bottom and cut away the saw cuts while giving it a little shape.

I want to shape his butt a little bit, even though it is hard to make anything out of a box.

The test fit shows me that a slight redesign is needed to take the belt a little higher.

You want to work the whole surface, except where the legs will be glued.

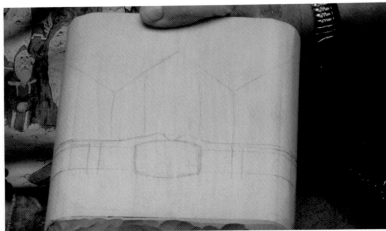

The redesigned body.

The legs are doweled in place for added strength. Test fit it now before continuing with the carving. Do not glue the legs in place until later.

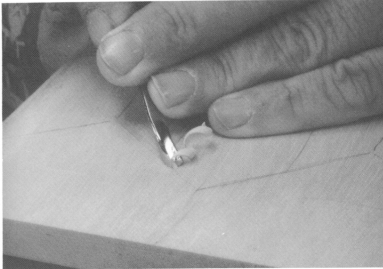

Go along the lines with a v-tool, keeping the side of the tool, away from the line, pretty flat to the surface of the wood. About all this does is create a stop against paint migration.

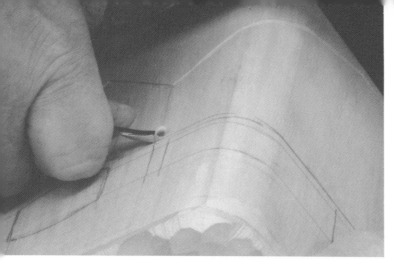

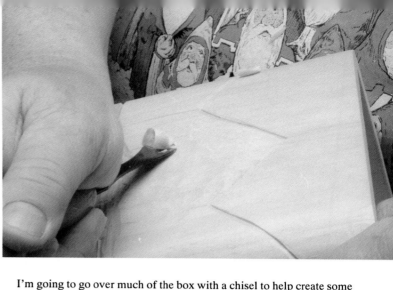

Do the same around the top of the pants and around the belt.

I'm going to go over much of the box with a chisel to help create some texture. I may leave the belt smooth for contrast.

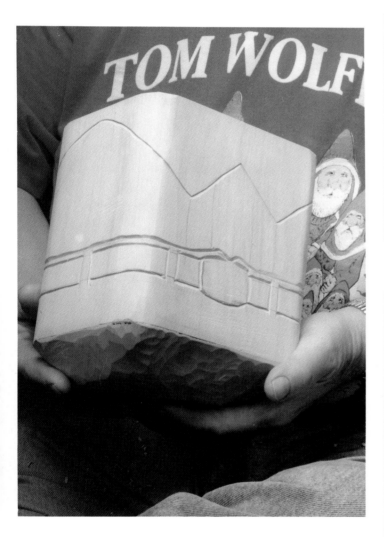

The outlining completed.

You may need to fill in some gaps with wood filler.

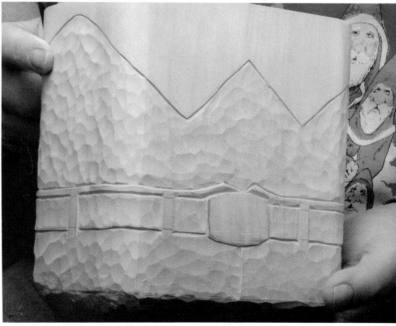

Progress.

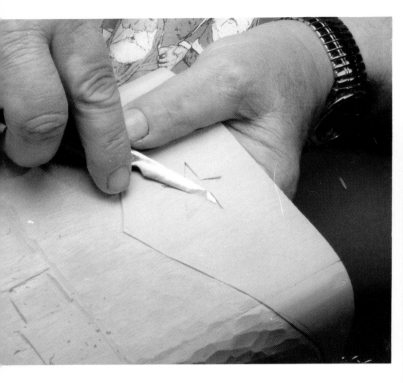

The top part of the shirt I'll keep smooth, so I relief cut the star by outlining it with a stop cut and trimming back to it from the inside of the star.

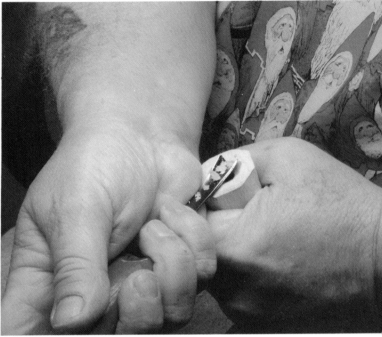

Before gluing the legs in place, I cup out the center. This will give me a better glue joint.

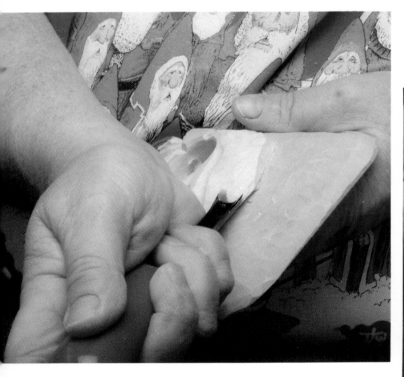

Add some folds to the neckerchief.

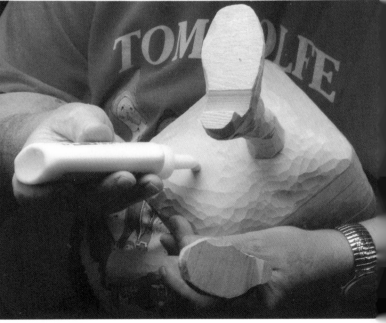

Apply glue to the dowel...

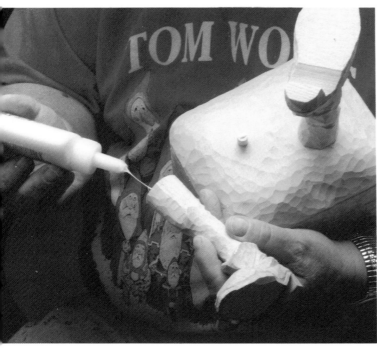

and the socket.

The base is a 7" square piece of mahogany with the edges beveled.

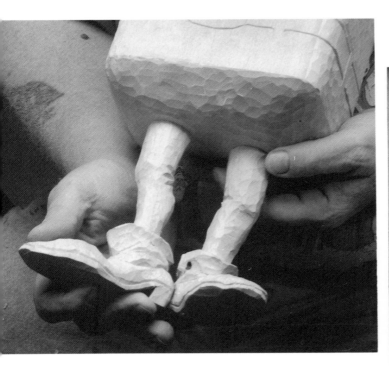

Glue them in place.

I'm going over the bevel with a knife to take away the saw marks and give it texture.

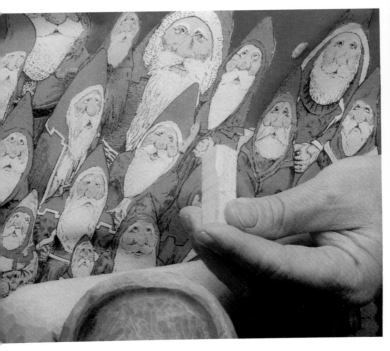

The cigar is simply made. Round over the corners of a rectangular blank to make the cigar shape.

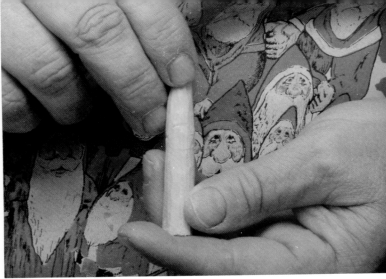

to make the curved edges.

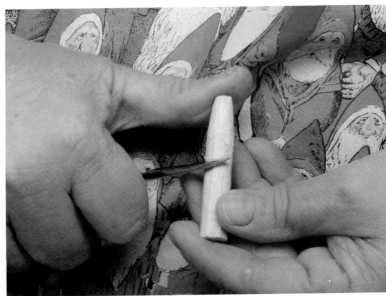

Trim back to the band from the cigar.

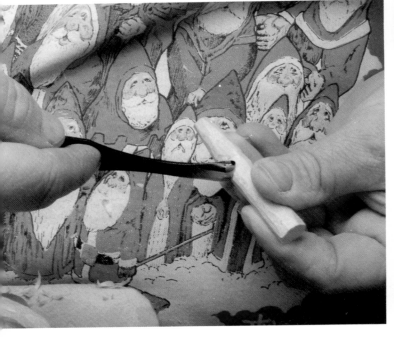

Create the band by pushing a gouge straight into the cigar...

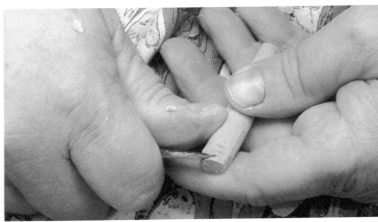

The ash is created by cutting little nitches. They will be dry brushed later with white to give them a realistic look.

Ready for painting.

Painting

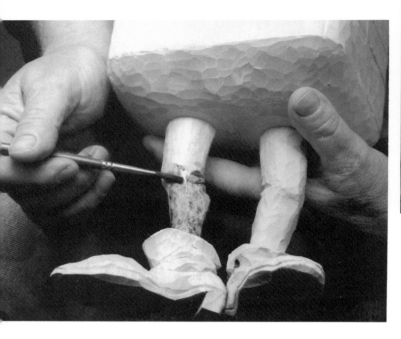

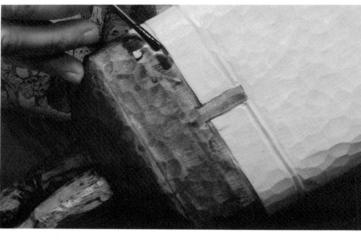

Move back to the narrow brush while you work near the edges.

Blue jean blue is blue with just a touch of purple in it, in a pretty diluted mixture. I apply it to the pants starting above the boots.

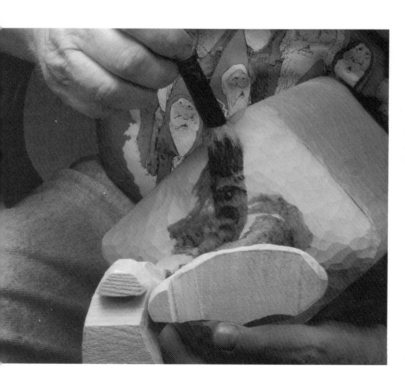

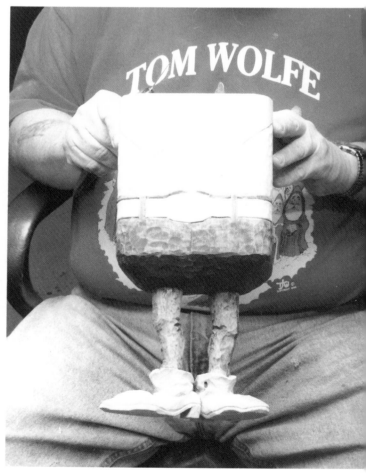

The pants finished.

As you get to the broader places you can use a wider brush.

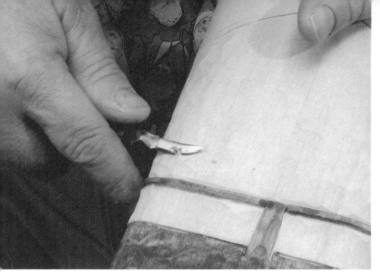

The "steel eraser" takes care of any splashes or other mistakes.

I dab away the excess, so it does not pool and hide the grain of the wood.

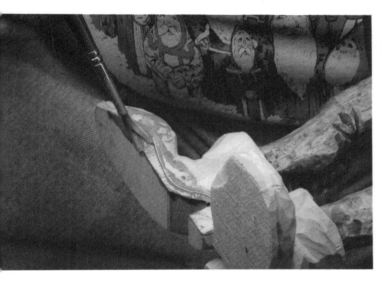

The boots are painted with a mixture of burnt umber and sienna.

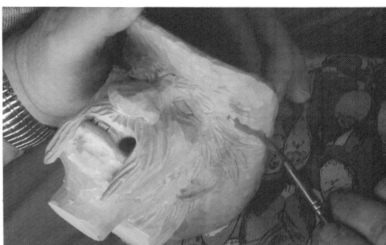

The hat is the same color, so I may as well paint it now. I usually start on the bottom. It fills the grain up underneath, avoiding run-through problems later.

Use extra care where the boot top meets the jeans.

Continue with the crown, working carefully around the brim.

Progress.

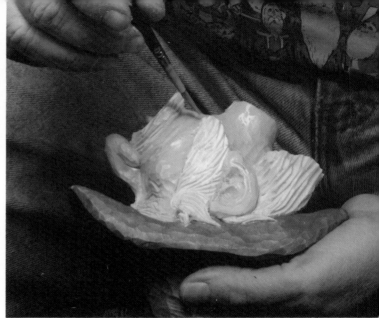

The flesh tone I use is mostly white mixed with raw sienna and a little pink or tube flesh. In this case I mixed it in the cup where the boot color had been, making it a little darker. Apply this to all the skin areas.

After the pants are painted I can glue the arms in place. I do one arm at a time to make things less complicated.

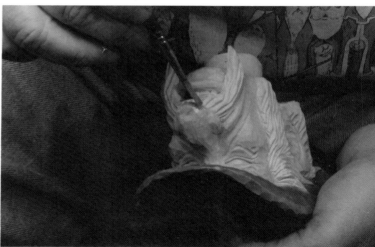

A dot of red at the end of the nose is blended in for a little blush.

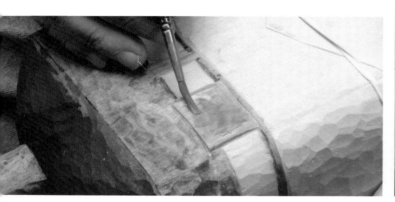

While that sets up, I can paint the leather patch at the back of the pants with the same color as the boots and hat.

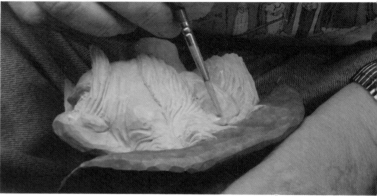

Add blush to the top of the ears...

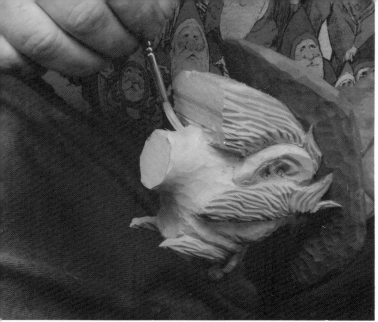

the back of the neck...

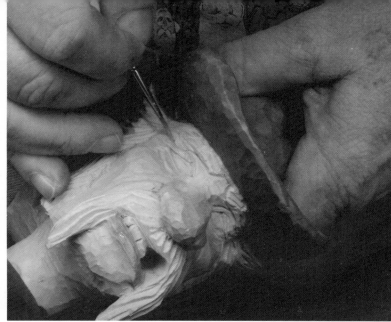

A little red around the eyes helps bring them out too.

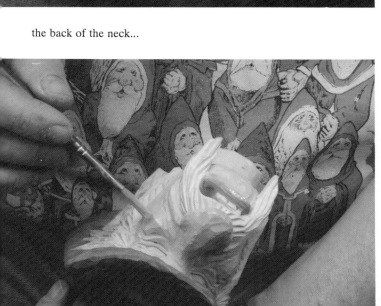

the cheeks...

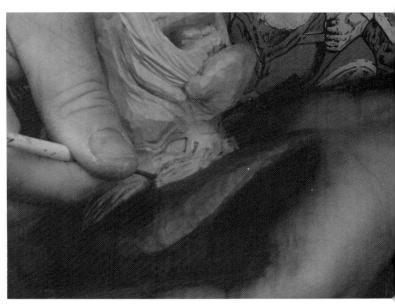

Burnt sienna added to the flesh tone is used to create shadow under the eye brow...

and the chin, with a heavier red on the lips.

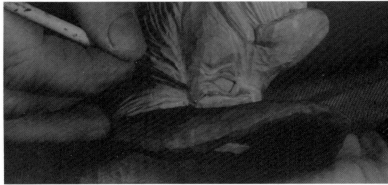

and at the temple along the hairline.

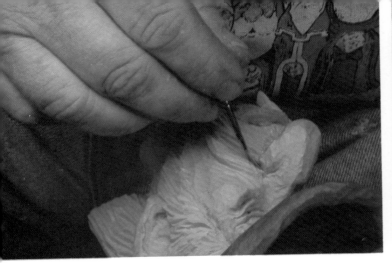

Use it anywhere else a shadow would naturally occur.

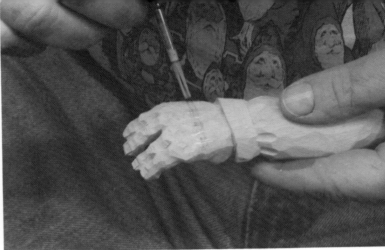

Then brush some red across the back of the hand and the fingers and blend it in.

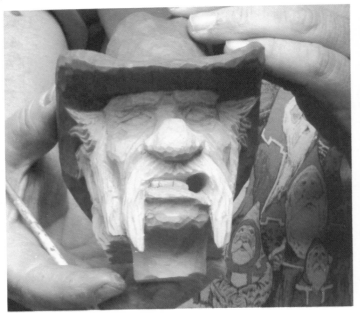

Progress.

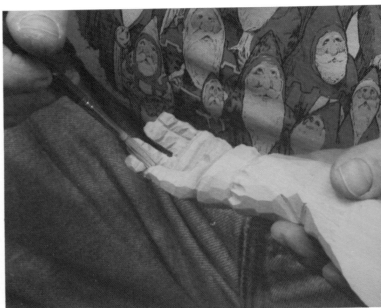

Paint the inside of the hand.

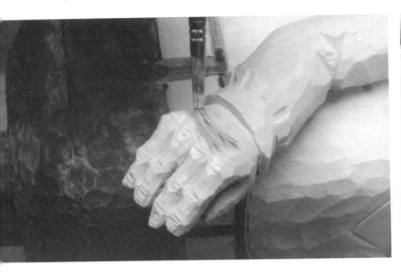

Paint the hands with the flesh tone

The top of the shirt is a sky blue, and continues on the upper part of the box. The rest of the shirt is red, including the star. Use the same red on the hat band.

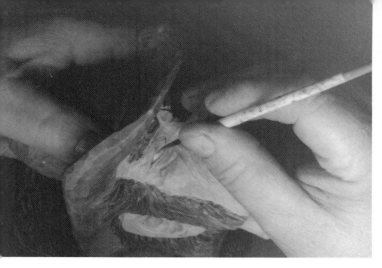

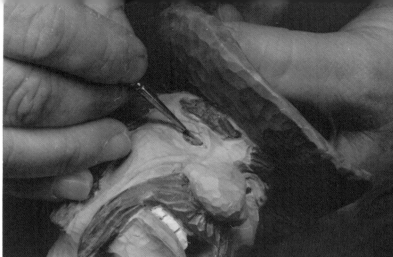

The undercoat of the hair is dark gray on this model, though you could certainly choose something else. Add a little white to the eyes. I don't want them too bright.

I use a lighter shade toward the center of the iris.

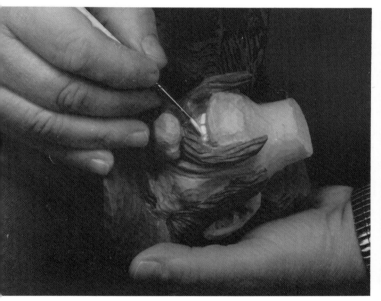

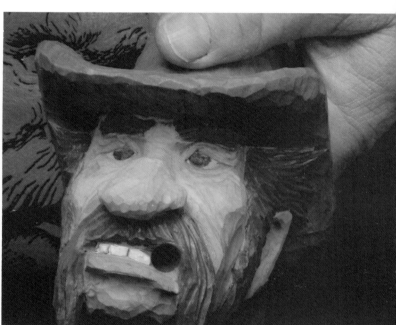

Also add some white to the teeth.

The result.

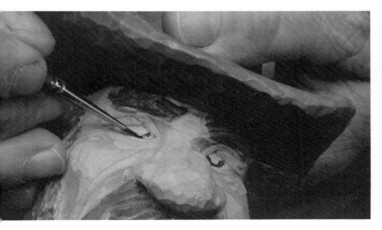

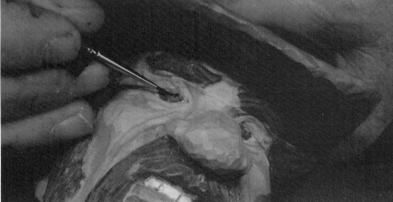

Add a ring of color around the iris.

Add the pupil. If the carving is big enough it is best to start with a circle and then fill the center.

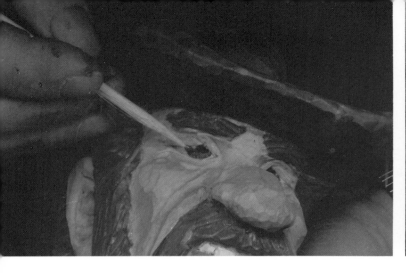

Now I am adding what the artists called refractive light to the eye. It is a dot of color, in this case green, added to the same position in each eye....

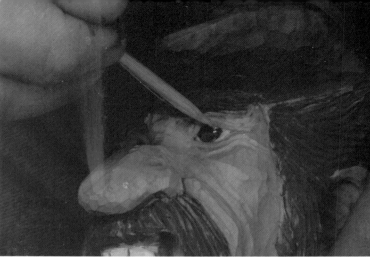

A dot of white on the edge of the pupil is the final touch. Notice I am using the sharpened point of a bamboo skewer for both of these operations. It gives me a lot more control.

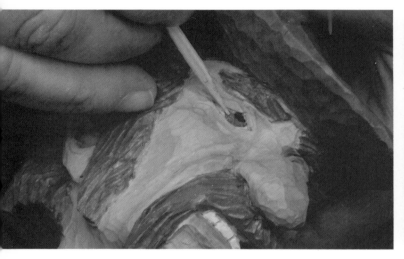

then blended into the brown.

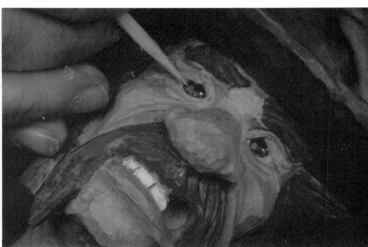

Going back with a little of the lighter eye color between the green and the pupil softens it up.

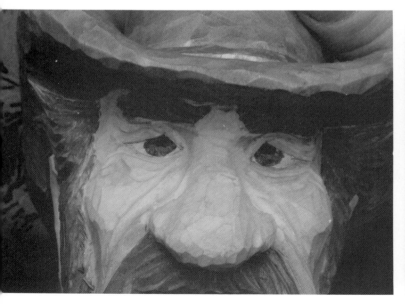

The result.

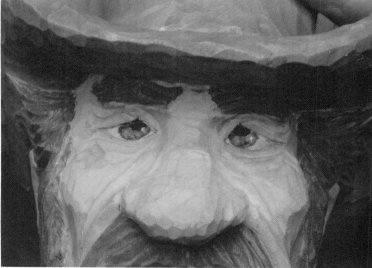

The result.

48

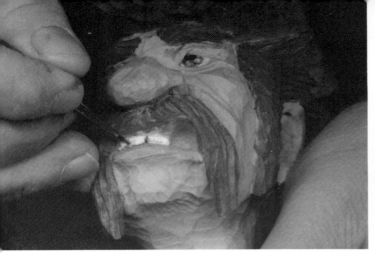

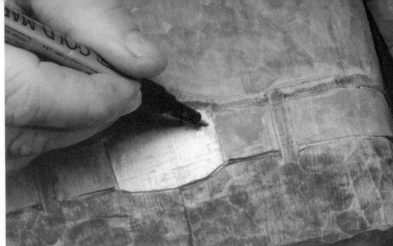

A touch of umber around the edges of the teeth give them a more weathered look.

and paint the belt buckle.

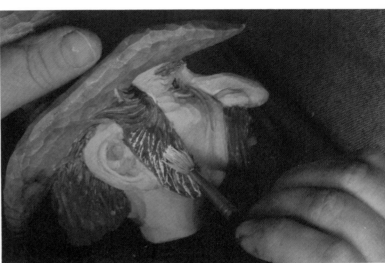

The cigar and belt are the same color as the shoes and hat. Paint the ash of the cigar black with a red dot on the end. With a bristly brush, barely touch the ash with white paint. For a finishing touch I use a gold pen to paint the cigar band.

Last but not least I dry brush the gray undercoating of the hair with white. Remember, I only want to get the ridges of the hair.

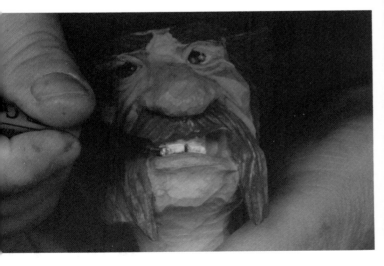

I use the same pen to add a gold tooth...

After signing the leather belt loop...

The Texas Troubadour Humidor is complete.

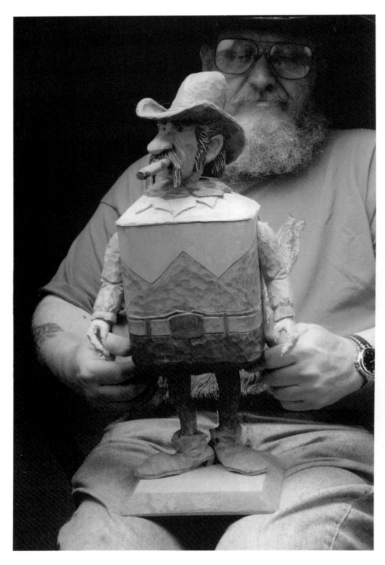

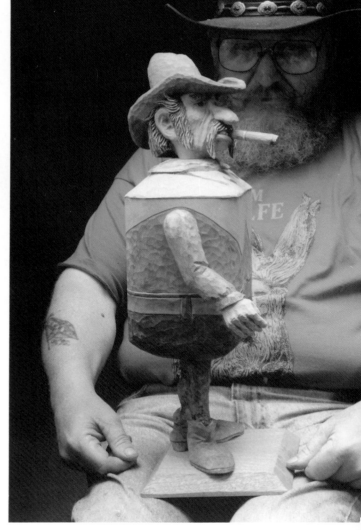

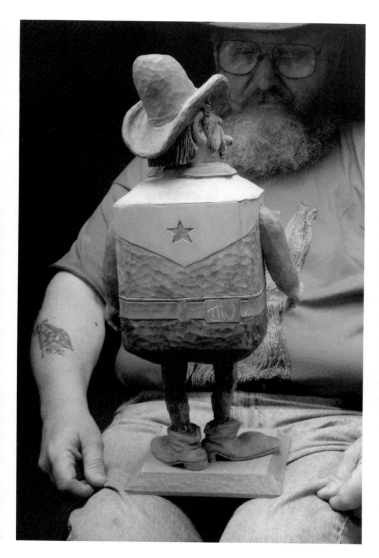

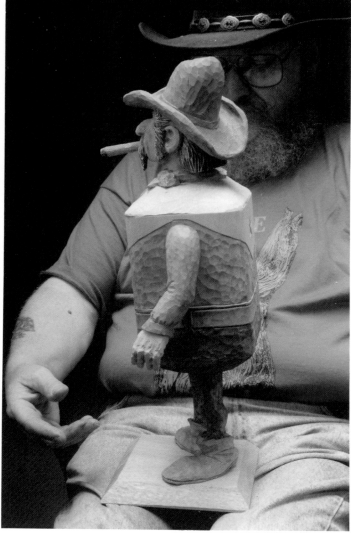

Gallery of Humidors

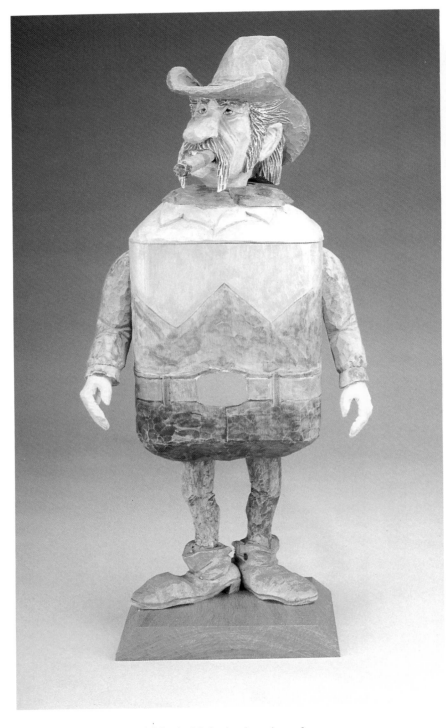

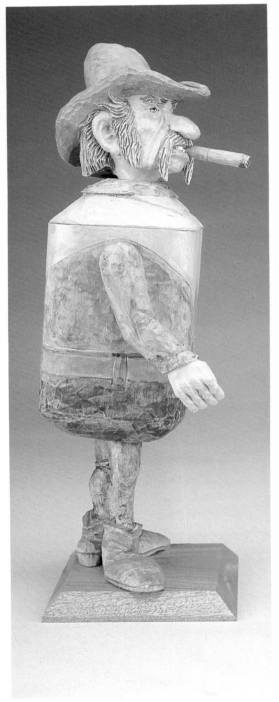

The main project. The humidifier in this is simply a piece of sponge covered with a "plastic canvas," a product used by cross stitchers. It is filled with a mixture of 50% water and 50% propylene glycol.

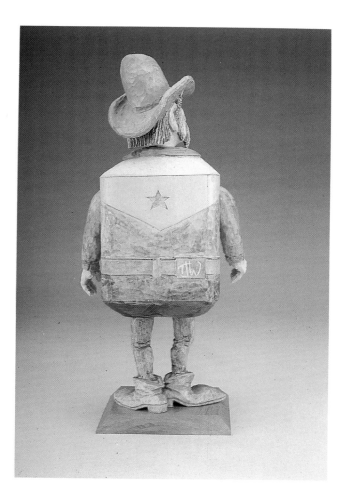

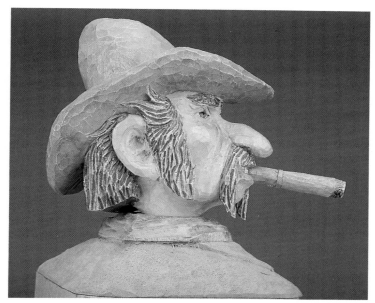

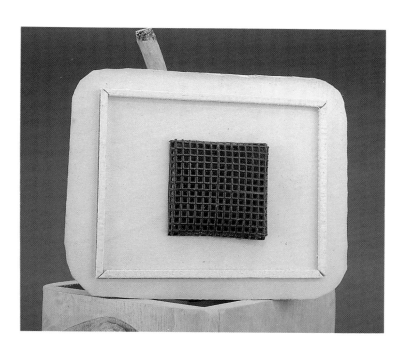

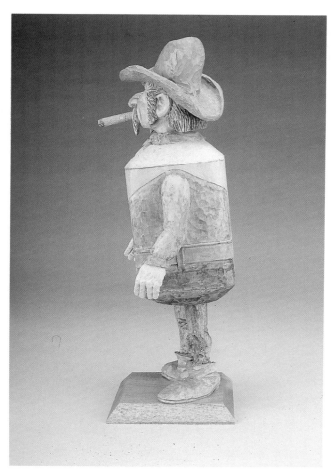

This little piggy smokes a big cigar. Standing atop the humidifier box, the top fits snuggly into the carved leg/corner posts.

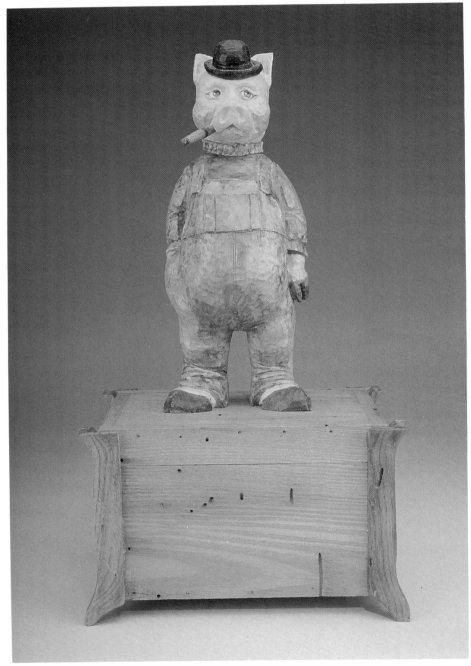

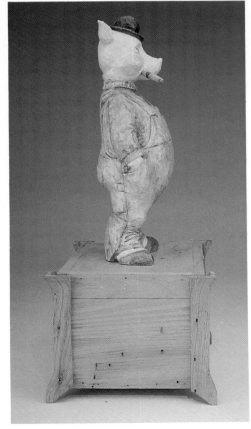

54

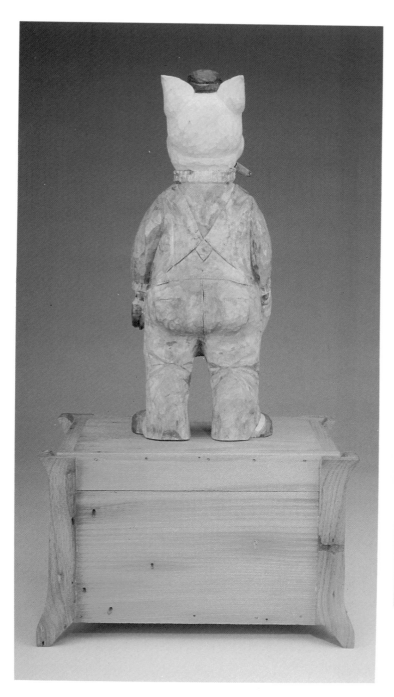

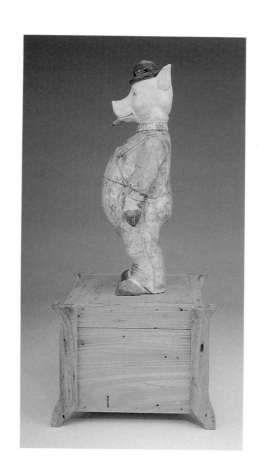

The basic humidor here is turned, with the nose, moustache, ears, and cigar carved and applied.

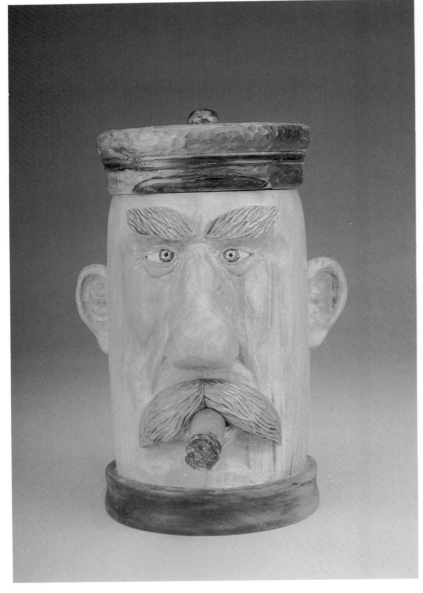

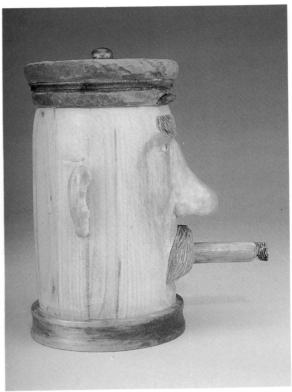

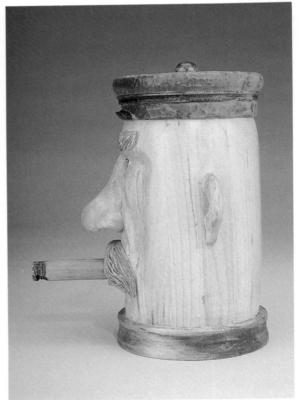

My friend, Robert St. Pierre of Hayesville, North Carolina, made the body of this humidor in his own unique style of craftsmanship. The carved fish is applied.

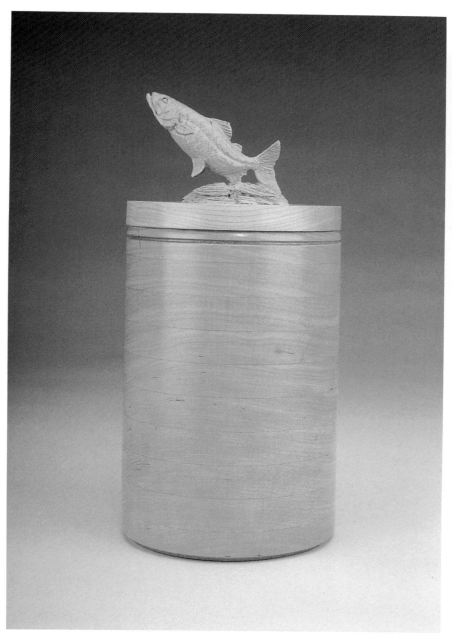

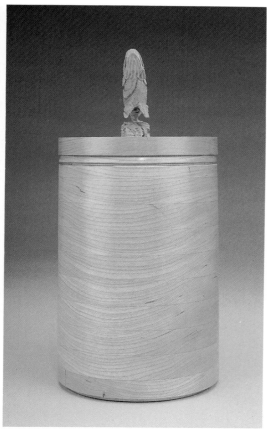

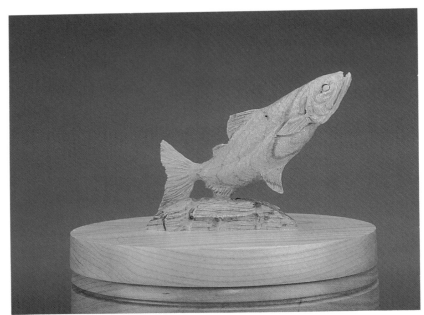

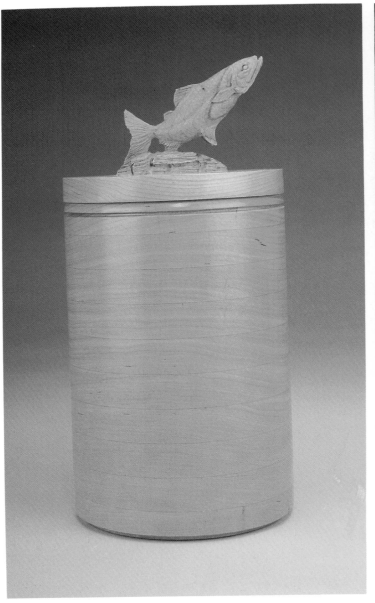

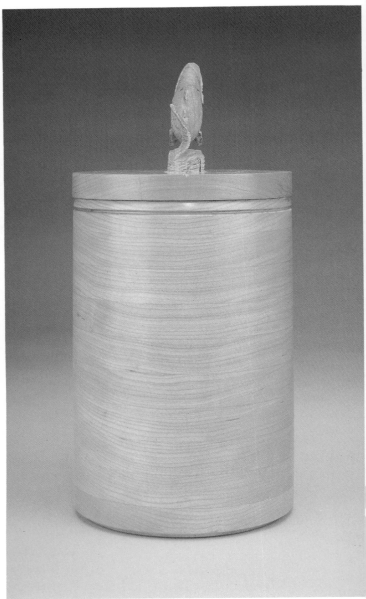

The humidor jar is a tall colored drinking glass with a nice octagonal shape. The top and the bottom are of wood and made to fit the jar.

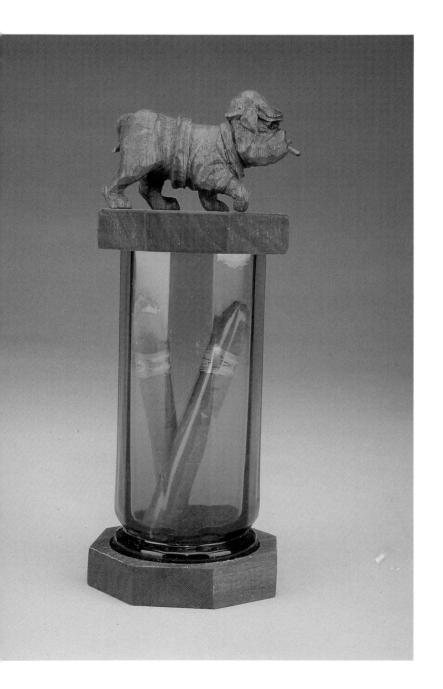

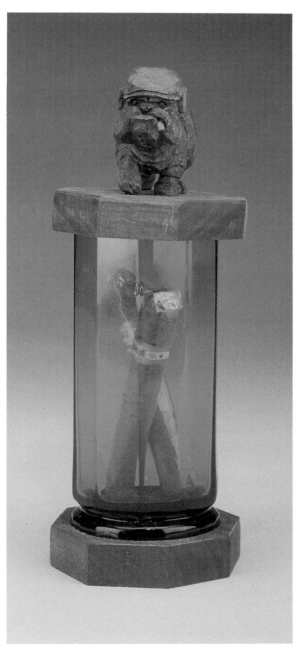

The humidor on the following page is a simple box construction, made elegant by the addition of feet at the bottom, and corners at the top which are designed to hold the lid securely in place. The fire breathing dragon seems a pretty good decoration for a cigar humidor.

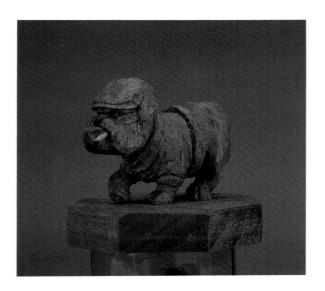

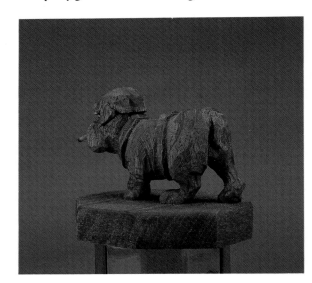

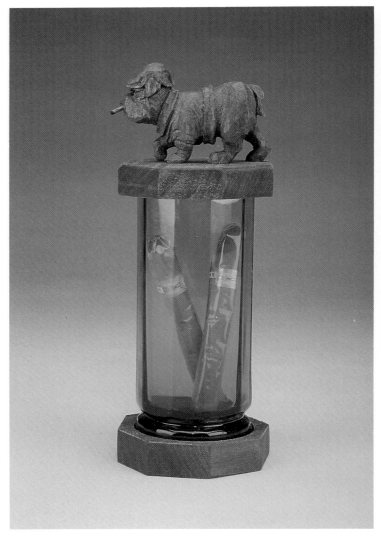

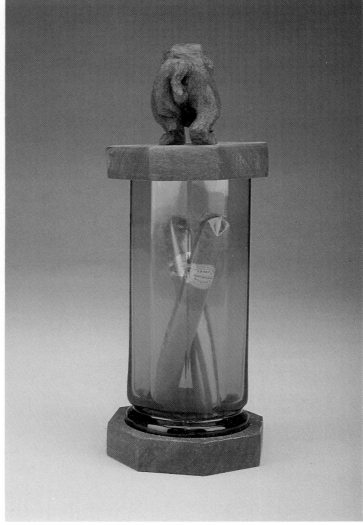

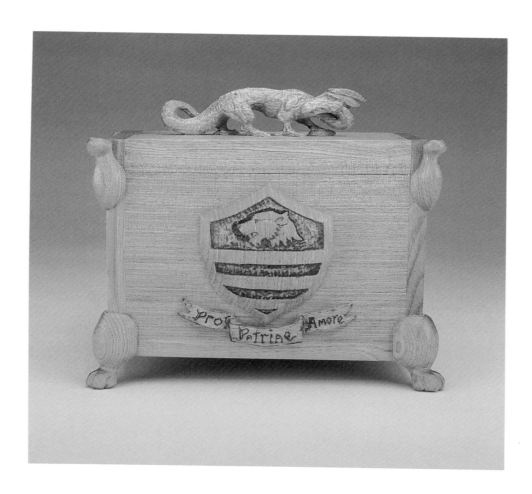

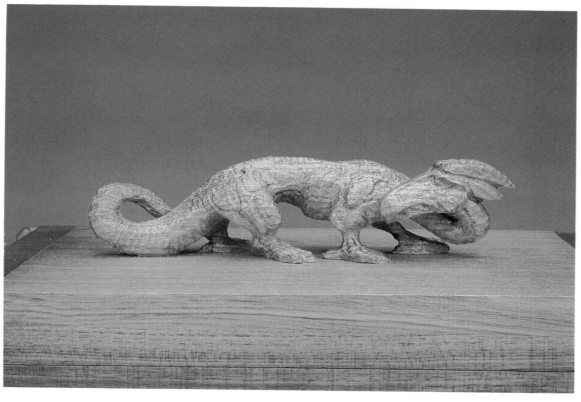

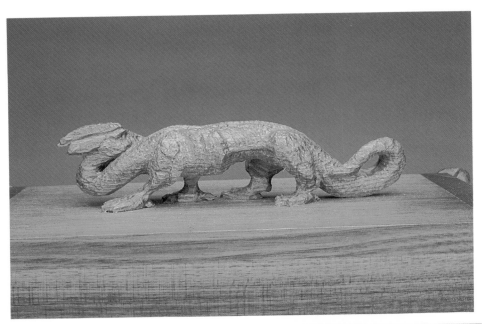

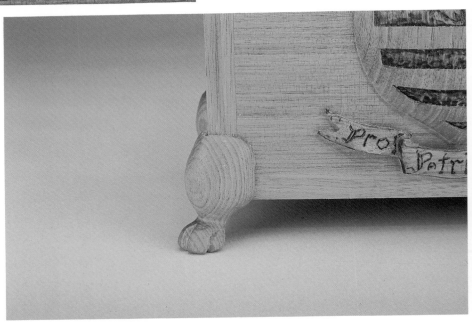

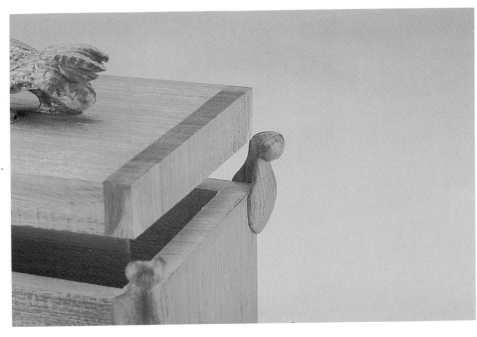

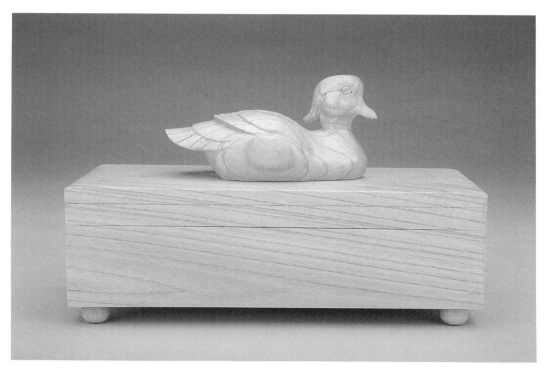

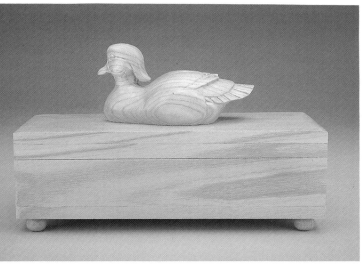

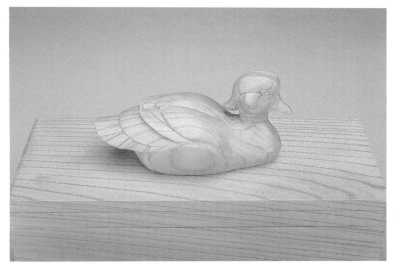

This humidor has a lip around the inside of the box to provide a tight fit. The humidifying element is a sponge and wire combination.

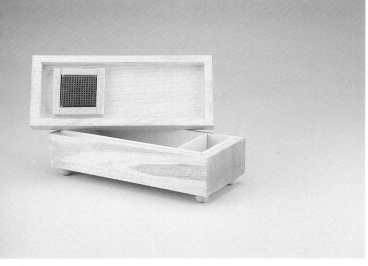

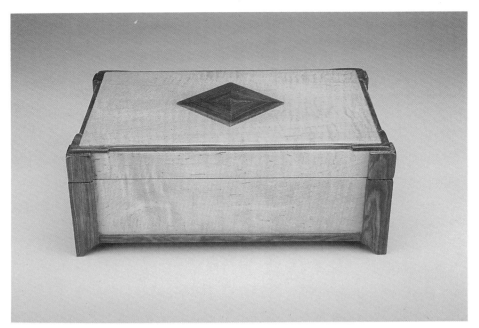

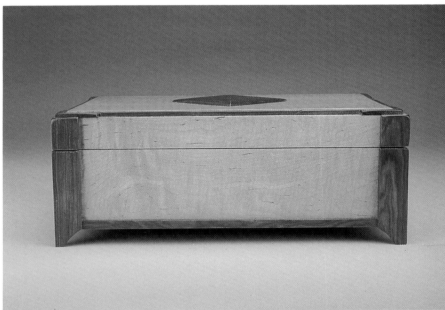

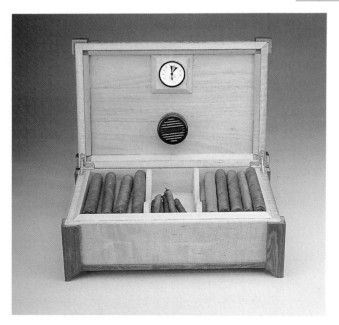

This is an example of the kinds of styles available from supply houses. I found this kit, courtesy of Woodcraft Supply, Parkersburg, West Virginia, to be quite beautiful and easy to assemble. It also demonstrates the fancier types of humidifiers and gauges that are available to the craftsperson.

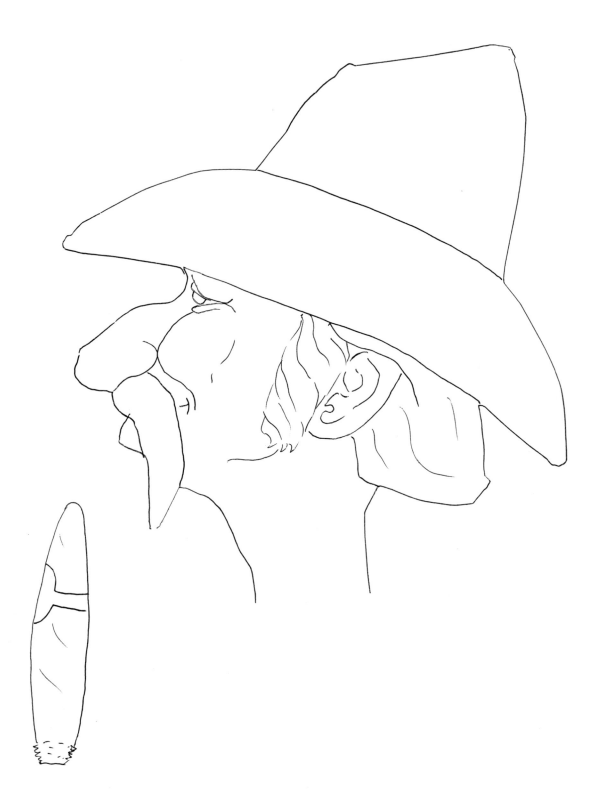

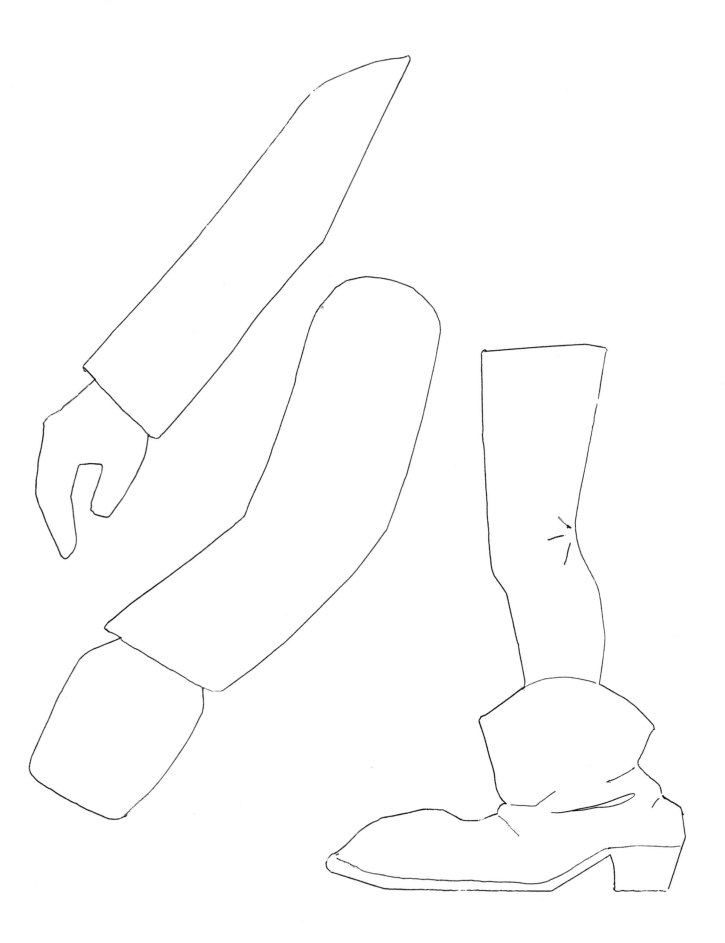

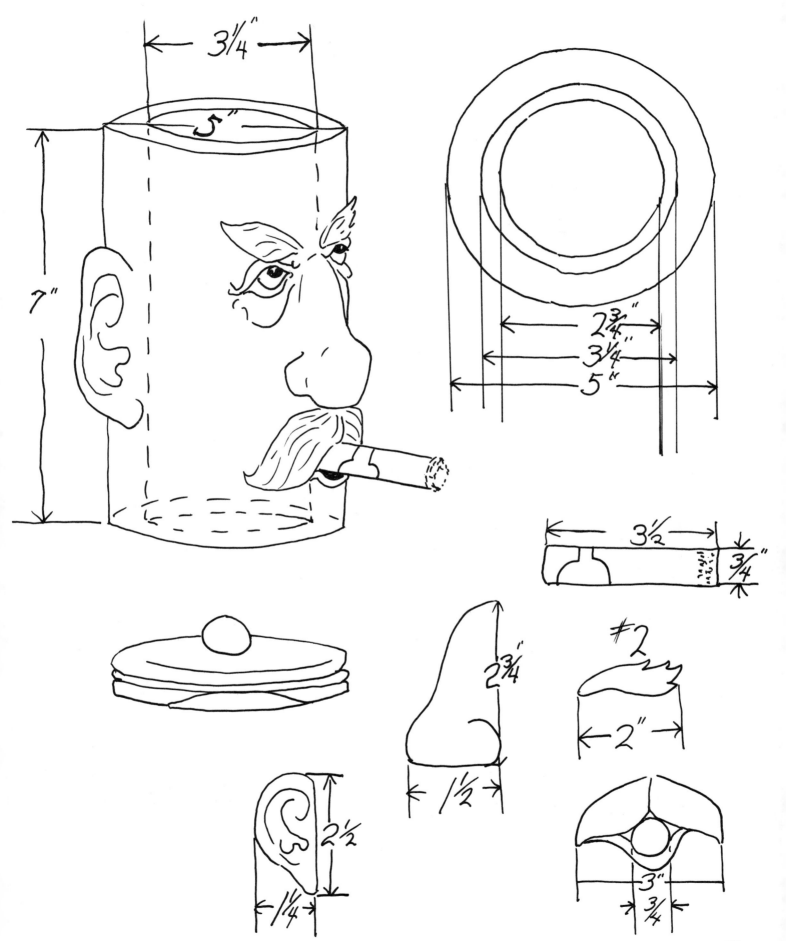

3¼"

5"

7"

2¾"
3¼"
5"

3½"

¾"

#2

2"

2¾"

1½"

2½"

¼"

3"

¾"

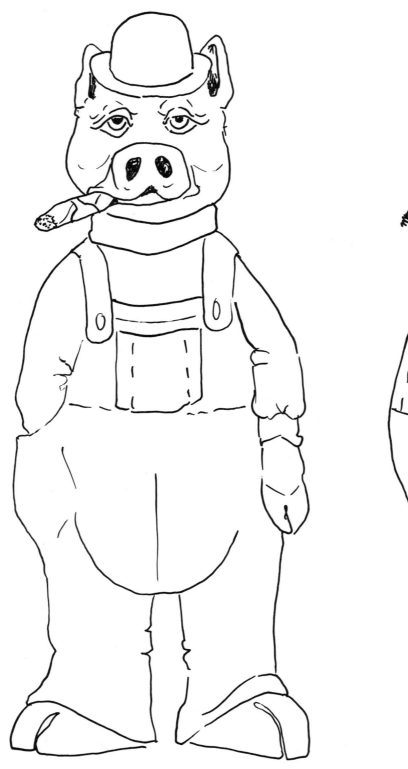
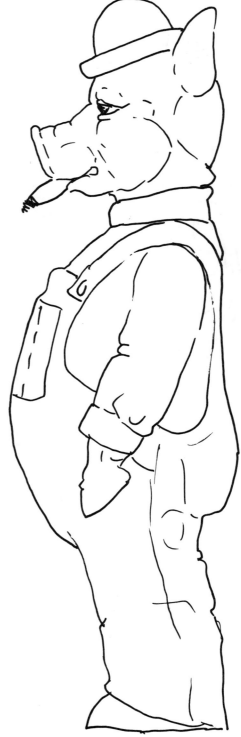

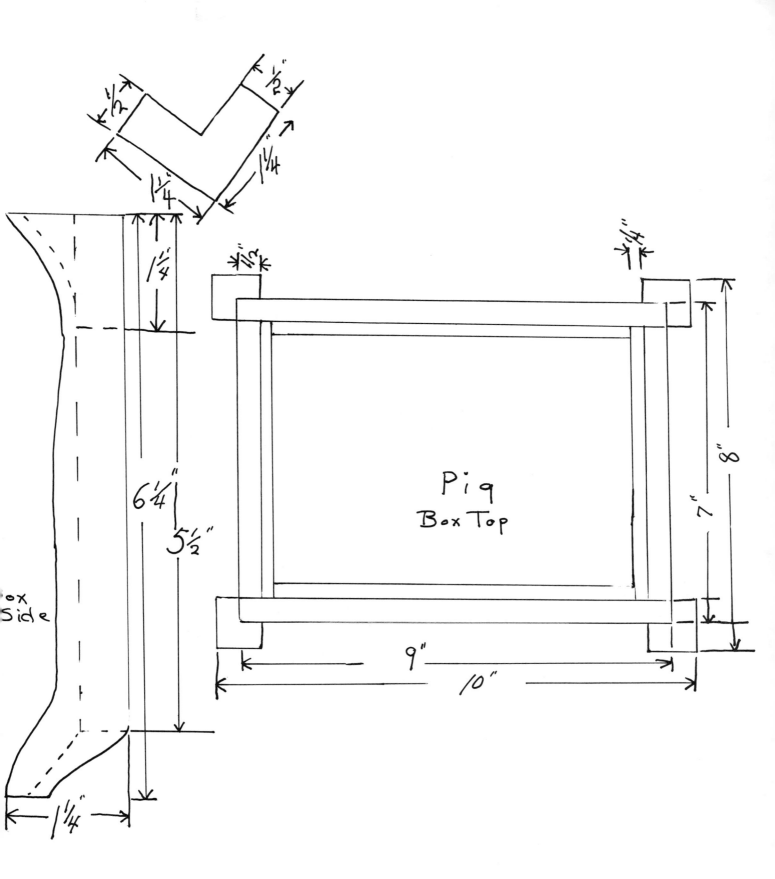

Pig
Box Top

Box Side

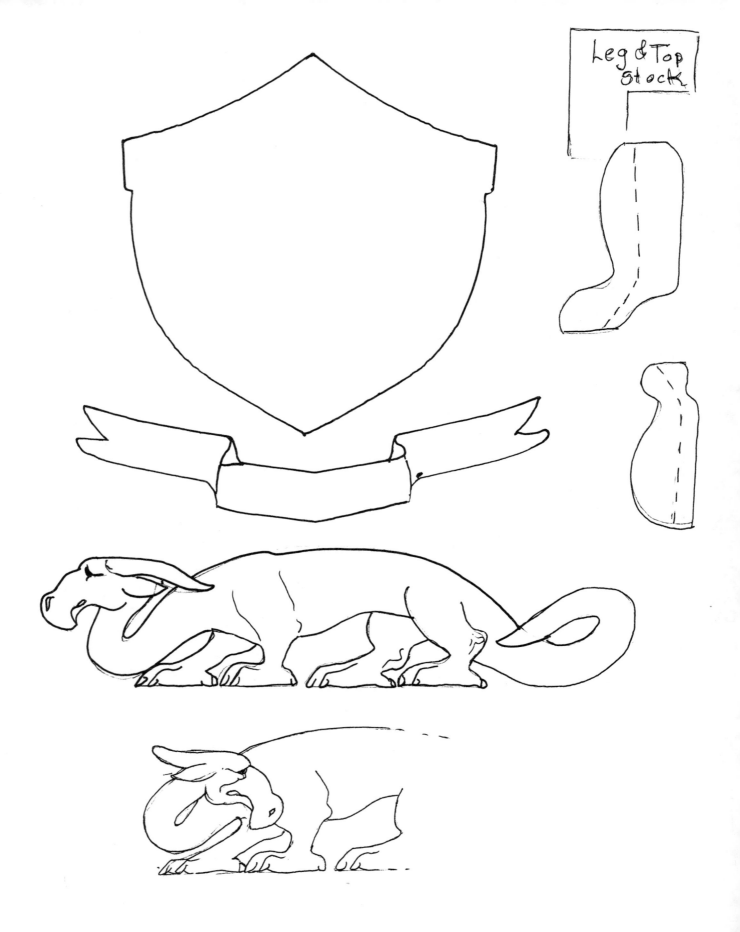

Leg & Top stock

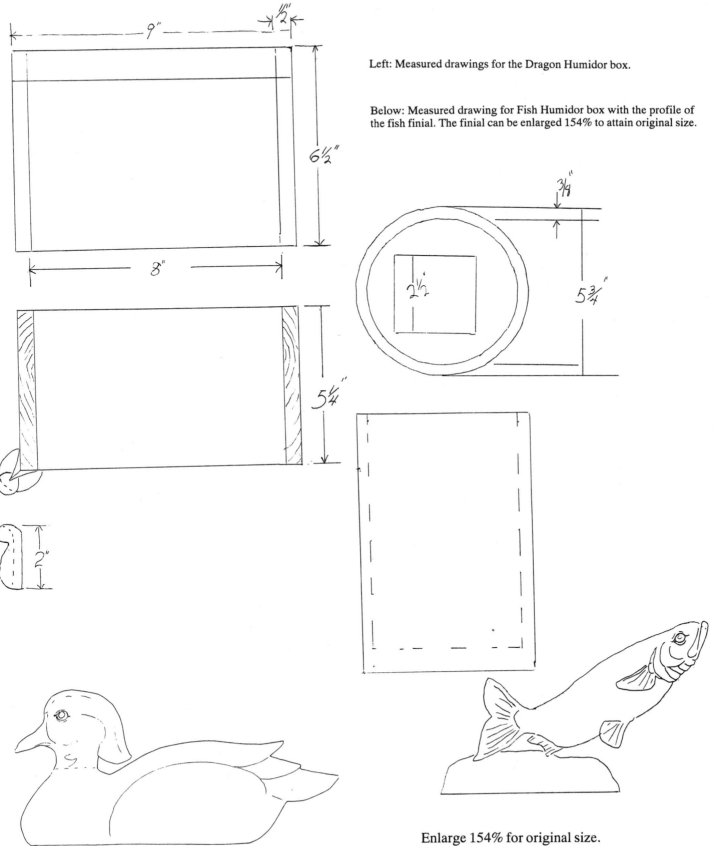

Enlarge 154% for original size.

Left: Measured drawings for the Dragon Humidor box.

Below: Measured drawing for Fish Humidor box with the profile of the fish finial. The finial can be enlarged 154% to attain original size.

Enlarge 154% for original size.

Finial for Decoy Humidor. Enlarge the duck 180% to restore to the original size.

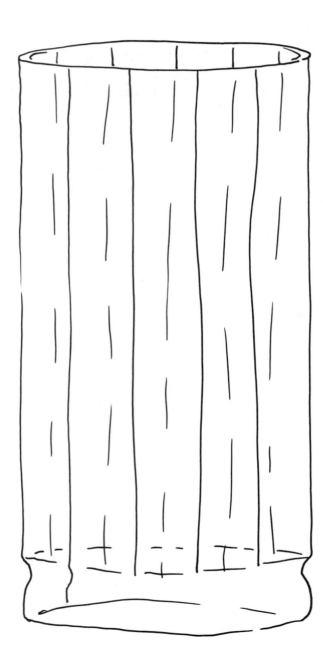

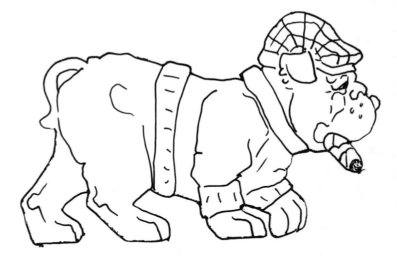

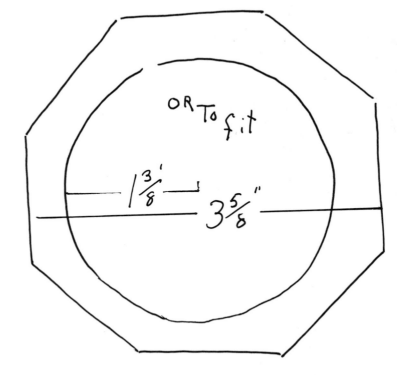

OR To fit

$1\frac{3}{8}'$

$3\frac{5}{8}''$

This is an example of the kinds of styles available from supply houses. I found this kit, courtesy of Woodcraft Supply, Parkersburg, West Virginia, to be quite beautiful and easy to assemble. It also demonstrates the fancier types of humidifiers and gauges that are available to the craftsperson.